NORTHERNERS
Portrait of a no-nonsense people

SEFTON SAMUELS

EBURY
PRESS

1 3 5 7 9 10 8 6 4 2

Published in 2011 by Ebury Press,
an imprint of Ebury Publishing

Ebury Publishing is a division of the
Random House Group

Text © Sefton Samuels 2011

Photography © Sefton Samuels 2011

Sefton Samuels has asserted his right
to be identified as the author of this
Work in accordance with the Copyright,
Designs and Patents Act 1988

The Random House Group Limited Reg.
No. 954009

Addresses for companies within the
Random House Group can be found at
www.randomhouse.co.uk

A CIP catalogue record for this book
is available from the British Library

MIX
Paper from
responsible sources
FSC® C008047
FSC
www.fsc.org

The Random House Group Limited makes
every effort to ensure that the papers used
in our books are made from trees that have
been legally sourced from well-managed
and credibly certified forests. Our paper
procurement policy can be found on
www.randomhouse.co.uk

Design: Blokgraphic

Printed and bound in China by
C & C Offset Printing Co., Ltd

ISBN 978-0-09-193893-2

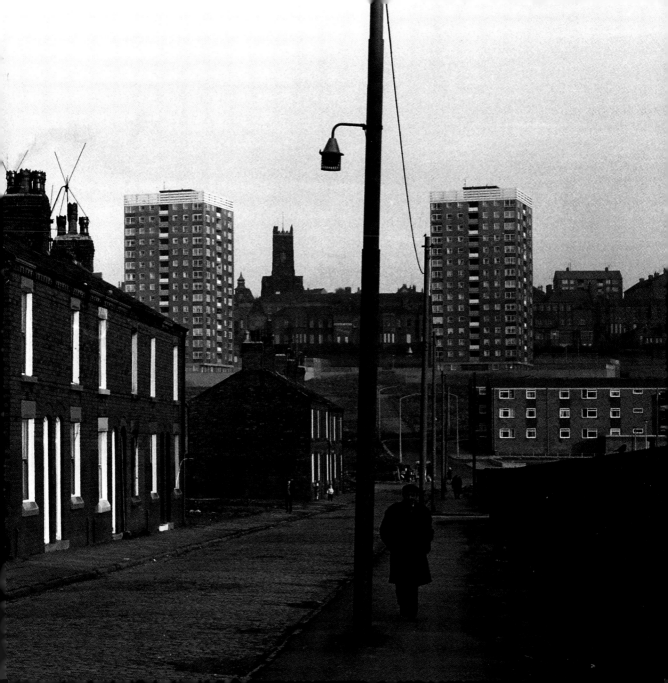

CONTENTS

FOREWORD

I'm biased. I live in the North; I love the North.
I don't hate the South. I love to visit.
But I don't love it like I love the North.

The world captured here in these evocative and often elegiac photographs is the North I knew through the lives of my grandparents: the smoke, the smoking, the mills, the lines of washing, the back alleys, the stoned steps, the day trips to the coast, the football, the bingo, the beer. But through the gloom and the grime, I can also see the aspiration of my parents' generation of Northerners. Like thousands of others, we were on the move from the blackened back-to-back terrace to the salubrity of the suburban semi-detached. We might not have been swinging like they were in that there London but nobody was going to deny us our carports or hijack our hostess trolleys.

Sefton Samuels is right to identify the IRA bombing of Manchester as a watershed. Mercifully no-one was killed, but out of necessity the re-development of the city centre was brought forward by a generation. Echoes and eerily unchanged snatches of landscape remain, but a lot of the old North captured here disappeared that day. It might have taken a few years for all the construction work to be completed, for the city to be sheathed in glass and chrome, but with it, something had gone forever. Which makes this collection all the more precious.

What Sefton Samuels, like L.S. Lowry, Tony Wilson, Morrissey and countless other proud Northerners understood, was that whilst it may well have been grim up here some of the time, there was also beauty, poetry and poignancy in the world we walked through every day. These pictures display not only his artistry, but his truth. It's about the sights, sounds and smells that have bombarded his senses since he was a lad. Technically his photographs are flawless, but ultimately it's not about that. Certainly he knew how to operate a camera, but far more importantly, he knew where to point it.

Northerners is subtitled: *Portrait of a no-nonsense people.*

I know what he means.

We do have nonsense of course, but it is a very particular kind, laid bare here in all its peculiarities.

And it is our nonsense. A no-nonsense sort of nonsense. The best kind of nonsense – but then again… I'm biased.

Mark Radcliffe
BBC Radio 2 & 6 Music presenter. June 2011

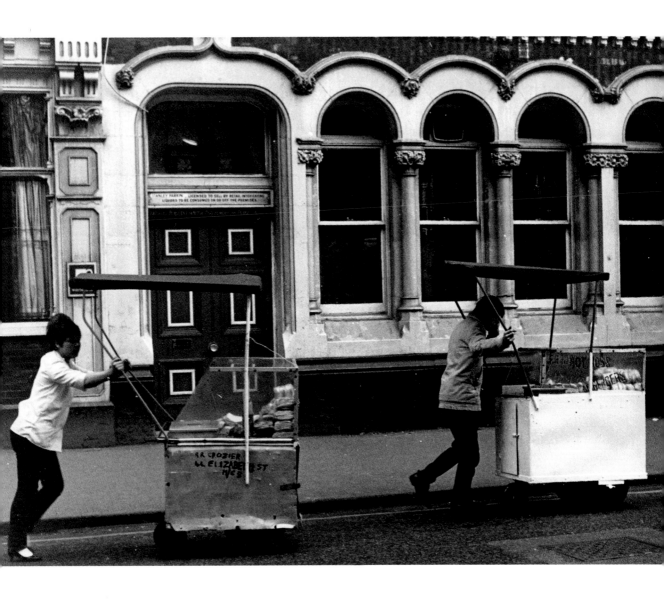

INTRODUCTION

As a photographer, you grab the moment. You want to seize that split second before it passes. It's a reflex: don't stop to analyse why you're taking the photo, just shoot. For 60 years I've been following those reflexes, without stopping to wonder if there's a common impulse at work. But I now wonder whether there is something that specifically tends to trigger my interest and makes me want to capture that instant –

sending my shutter-finger into action?

As odd as it sounds, it's a question I'm asking myself for the first time as I look at six decades of my pictures of Northern England laid before me. And the common thread which now stands out to me is 'character'.

There is an unmistakeable character that permeates the North, but it's hard to pinpoint exactly what it is: you

ABOUT THE AUTHOR

Sefton Samuels is one of Britain's most iconic photographers, with a career spanning six decades.

Described by painter L.S. Lowry as his favourite photographer, Sefton has been called 'the photographic equivalent of Ken Loach'.

He has more than 100 images held in the National Portrait Gallery and the Victoria & Albert Museum – and has exhibited at the Barbican Centre, Kings Place and Proud galleries.

Before turning to photography, Sefton worked in mills across the North West and as a professional jazz drummer.

He is a Fellow of the Royal Photographic Society and still lives in his hometown of Manchester.

feel it when you're with other Northerners; you sense its absence when you get off the train at Euston. And, I hope, you see it when you look at this collection of photographs. Impulsively, I've tried to bottle that Northern character – with its dark humour, no-nonsense toughness, informality, pride, contrariness and rich cultural expression.

Pontificating about what it means to be Northern almost goes against its essence – and it certainly runs against mine. I've always preferred to let my photos articulate for me – photos which (not to sound too Southern) fall into the realism school of social documentary. From the wings, I try to capture scenes as they are – using natural light, passing no judgement, yet instinctively being sympathetic to the subjects. I would humbly cite Robert Frank's *The Americans* as inspiration for *Northerners*.

It has certainly been a character-building life along the way. While photography was a passion from childhood, my route there was circuitous. Having left school at 16, there were no clear routes to making a living using my box camera, so for some reason I ended up going into the textile industry – at precisely the moment it was starting to collapse. Working in mills, living in freezing digs in Yorkshire, wasn't the Cartier-Bresson path I'd pined for. Nor, despite my best efforts for a year, was professional jazz drumming going to be my salvation. But other than when occupied by drumsticks, there was always a camera in hand – and I was eventually able to leave behind the looms and indulge in photography full-time.

Criss-crossing the North for decades has been a journey of extraordinary places and people. It's been a privilege to capture the real nature of cultural and sporting heroes – to sit at home with Lowry (and almost make him smile), see Barbirolli in full flow, observe a relaxed George Best up close and even witness Man City win silverware. Arguably less pleasurable but equally uplifting has been to head deep down into stifling coal mines in their last days, or see the aftermath of Moss Side and Toxteth after rioting.

It's also been a privilege to witness first-hand a region undergo profound change. The post-war gloom lingered long in the North. While London was swinging, parts of the North were racked with a Victorian-like poverty. The area that had given the world modern industry was, by the 1980s, home to pockets of terrible unemployment. But the North has picked itself up by its bootstraps. Spurred by the adversity of a terror attack, Manchester has never looked back. Across the region there's an infectious confidence: even in its bleaker times, it had an optimism which was inextinguishable – the North continued to turn out the best humour, music, football.

I'm proud to be a Northerner, and I am incredibly proud to have the chance to bring together this collection of photographs as a book – to collect together decades of those reflexive split-second moments.

[signature]

Sefton Samuels
www.seftonphoto.co.uk

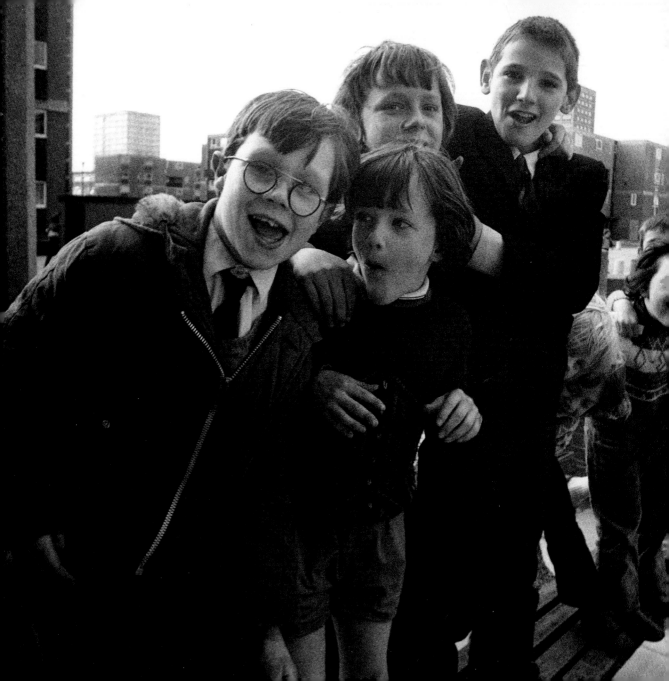

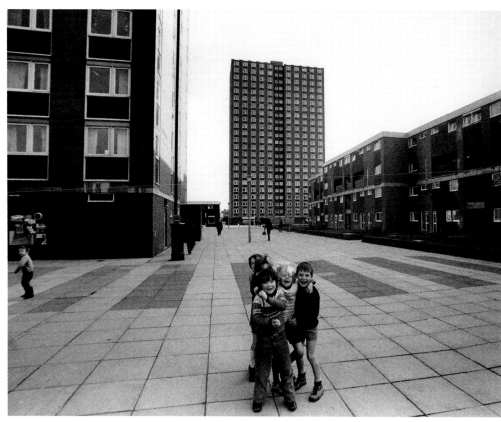

SALFORD LADS CLUB

Parkas, flares, NHS specs and an irrepressible cheekiness on
the high-rise estates of Salford in 1972 – back in the days before
gentrification, the Lowry Arts Centre and the BBC moved
into town.

It might not look out of place in Victorian times, but the lads playing in a cart in the back streets of Salford were photographed in 1962 – there were limits to how far north the Swinging Sixties reached.

RIGHT Kids playing on the cobbled pavements of Bacup, Lancashire, 1981.

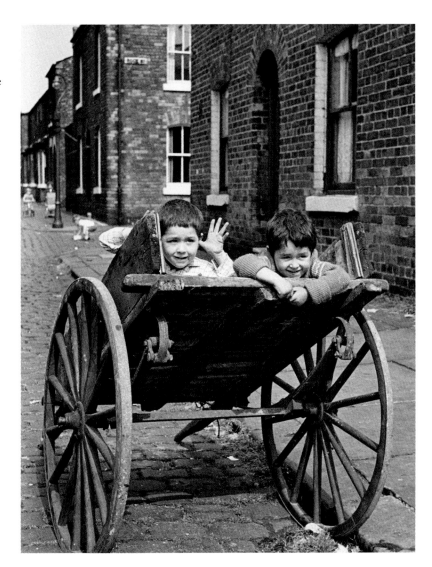

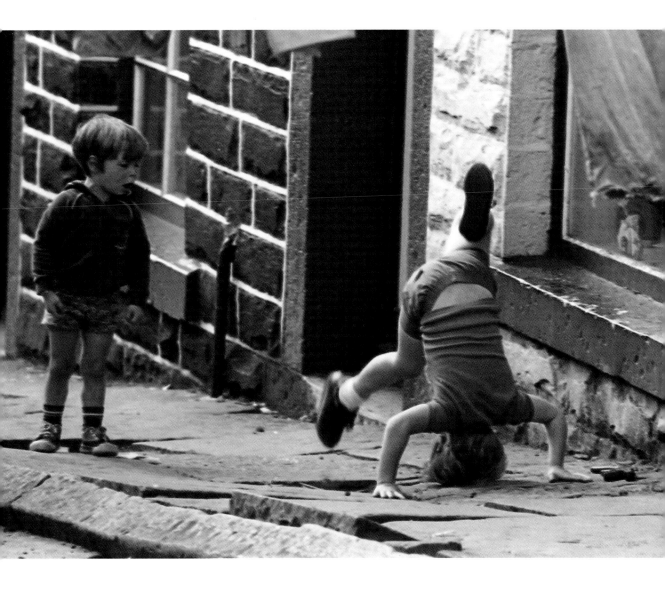

SCRUFFY STUDENTS

Well, it's all relative. Here I am with my fellow students at Huddersfield Tech – where I studied textile technology, before starting work in the mills – striking a pose with a passing dog and the only car on campus, 1950.

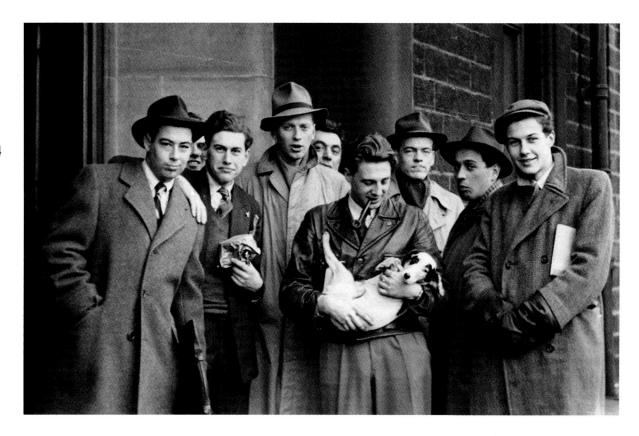

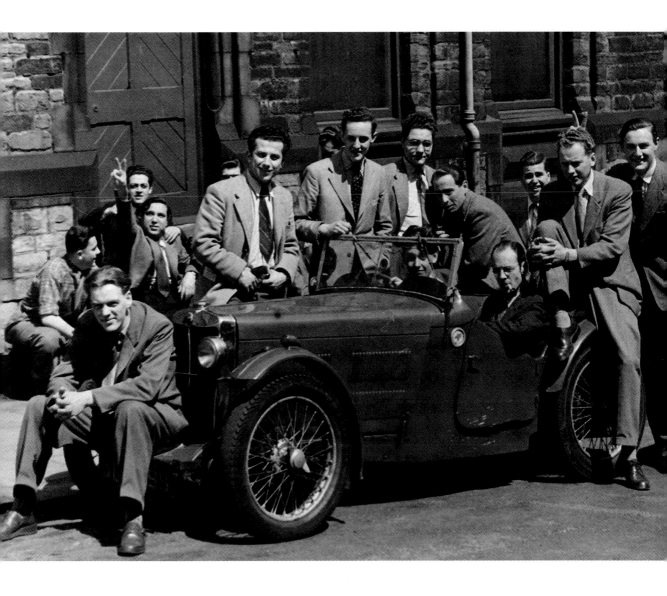

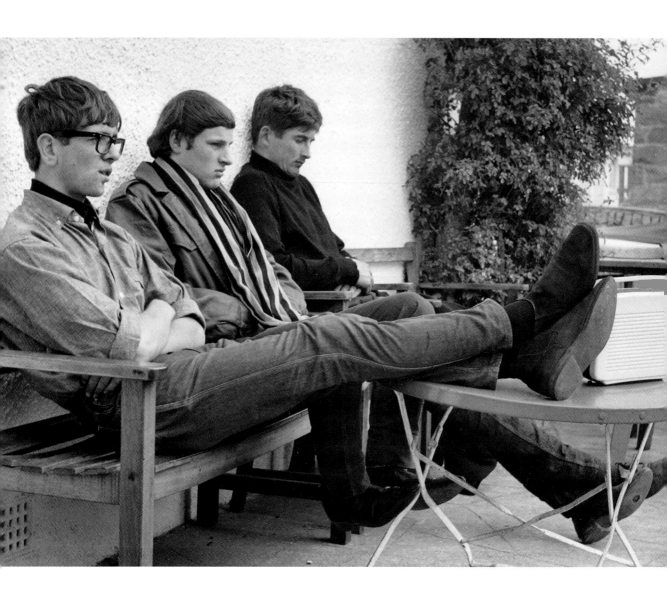

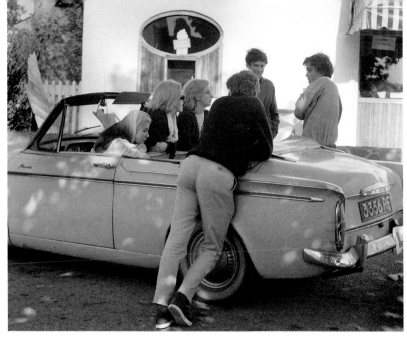

EVERY DAY IS LIKE SUNDAY

Known as Manchester-on-Sea, Abersoch in north Wales is where many a family escaped for the summer in search of something beach-like. But there wasn't an awful lot to do there, apart from hang around and work on a Mod look – or sleep off lunch (OVERLEAF), 1964.

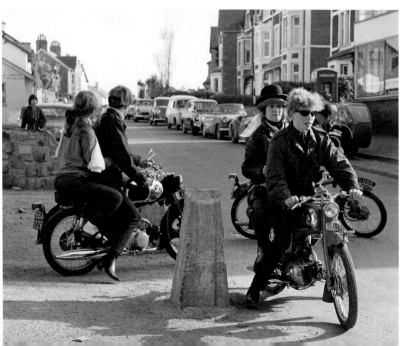

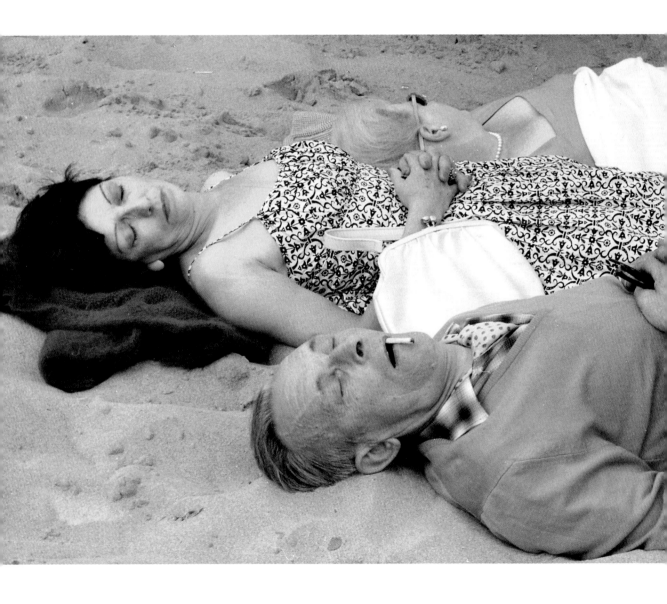

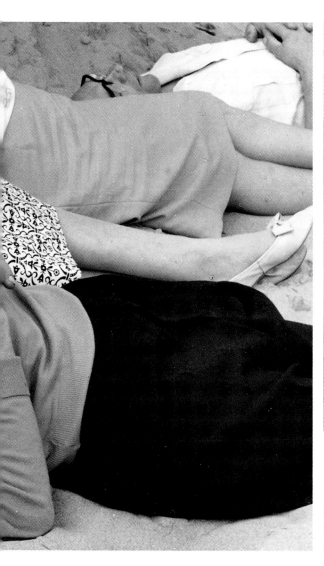

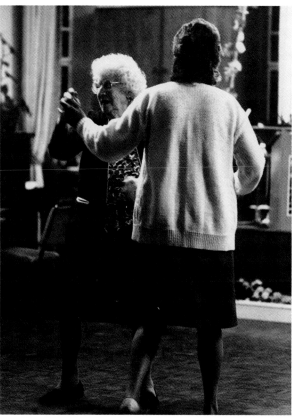

Sleeping off that lunch in Abersoch – and
(RIGHT) a carer and resident share a dance
at an old people's home in Manchester, 1991.

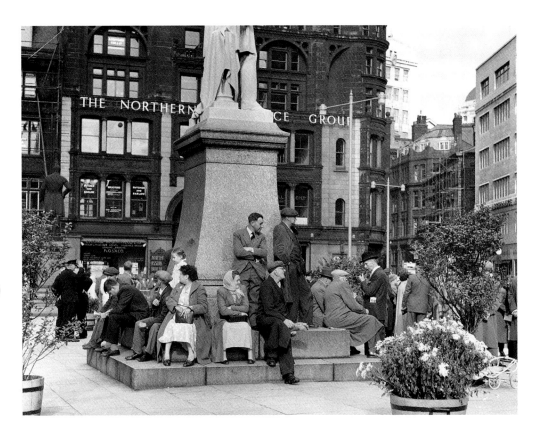

A slice of 1958 life in Albert Square in central Manchester –
and (RIGHT) the residents of Didsbury celebrate the 1981
Royal Wedding of Charles and Diana.

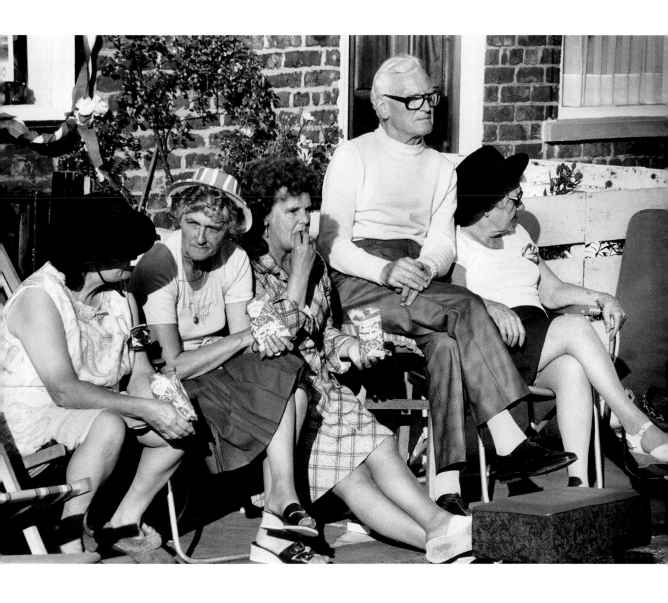

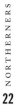

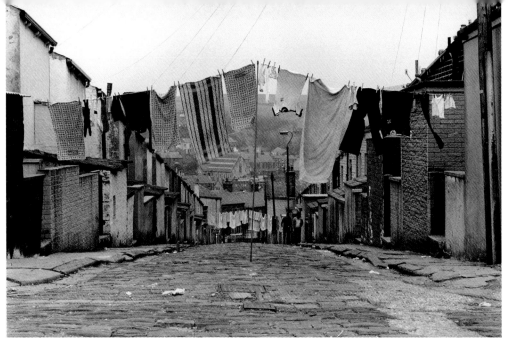

The steep cobbled streets of Bacup – a Lancashire mill town once dotted with cotton production. With its distinctive architecture, the centre of town has become a conservation area – preserving the tone of a place once at the heart of the Industrial Revolution. It's unclear as to whether the couch has been preserved, 1981.

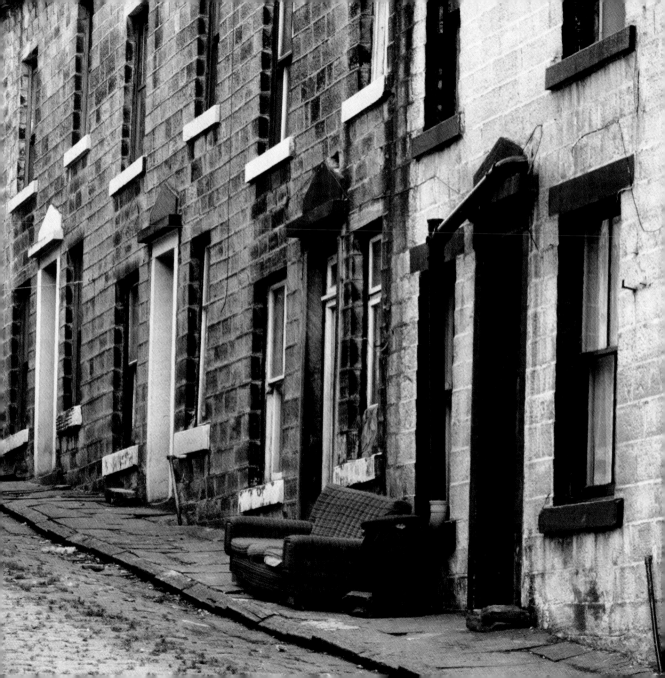

NORTH ON SCREEN

An unprepossessing cafe in Holmfirth, West Yorkshire – but a tourist mecca for fans of the long-running BBC sitcom *Last of the Summer Wine*. The series, which followed a trio of old men and their cronies, was shot in real locations around the town – including the cafe frequented by the Compo character.

RIGHT Not a stocking in sight, but the house where Nora Batty lived on screen, 1983.

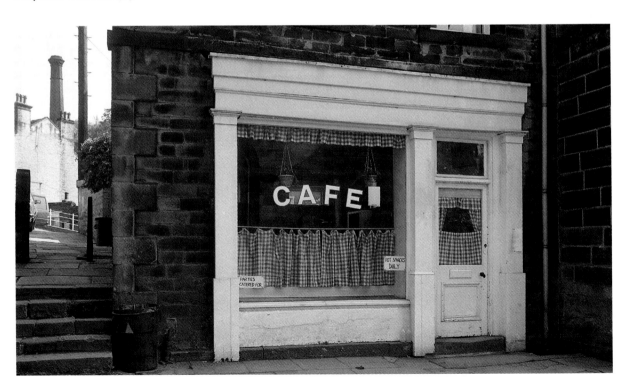

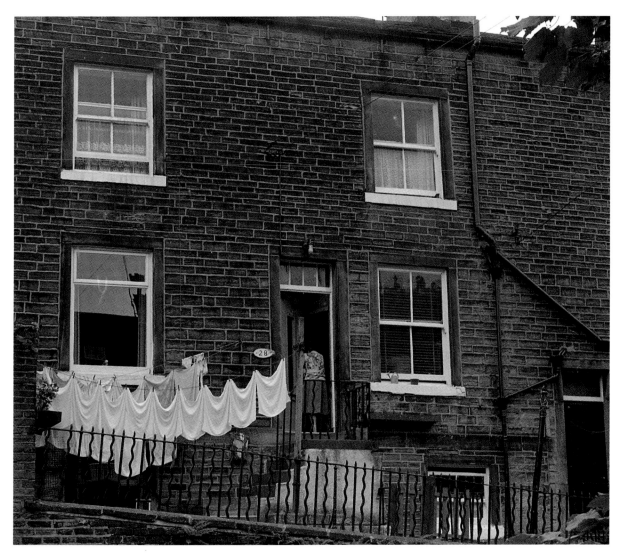

The golden era when *Coronation Street* was born and flourished under writers such as Jack Rosenthal – regularly pulling in more than 20 million viewers. I was allowed rare access onto the Granada set in 1968 during filming, capturing the likes of Stan and Hilda Ogden having breakfast.

RIGHT Rovers Return landlord Jack Walker behind the bar and seductress Elsie Tanner cosying up to Ken Barlow. Tanner was played by Pat Phoenix. There was just such an aura around Pat – former Prime Minister James Callaghan described her as 'the sexiest thing on television'.

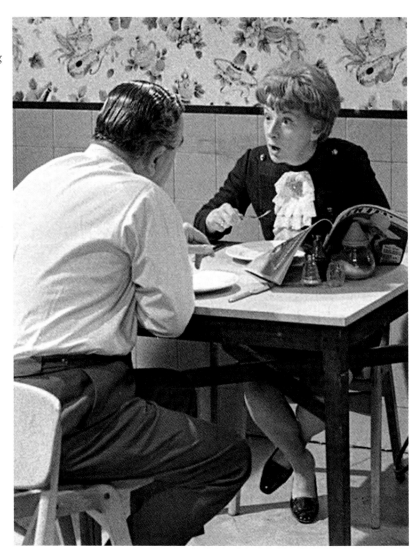

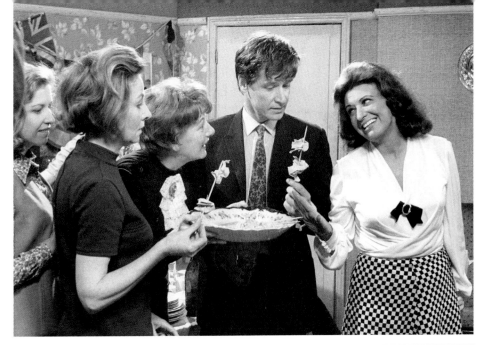

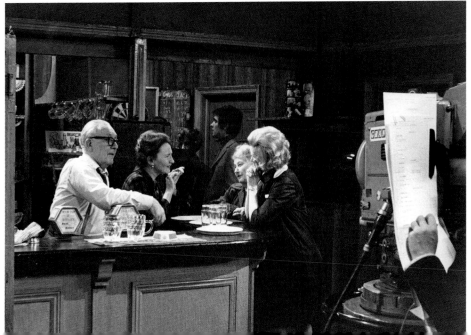

THE REAL CORONATION STREET

The back streets of Salford were the inspiration for the soap being filmed a few miles away. Taken in 1962, two years after *Coronation Street* began transmission.

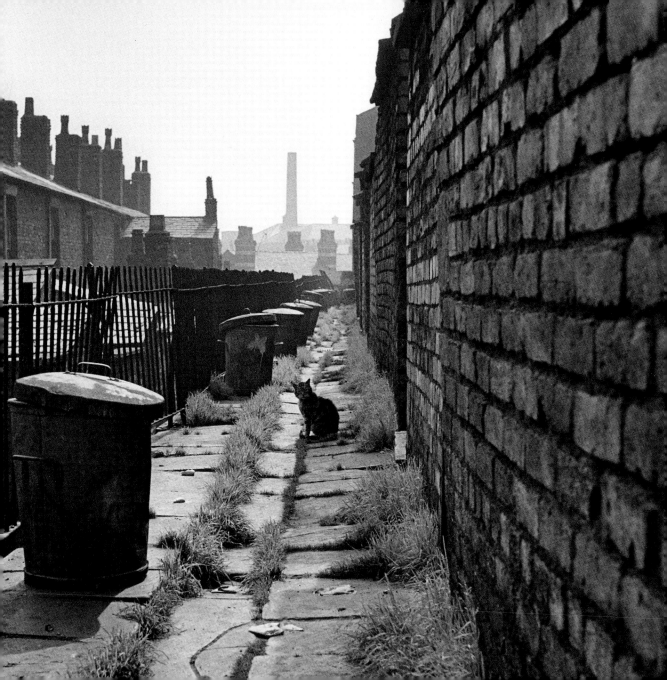

SALFORD LADIES

Coronation Street's creator Tony Warren placed strong women at the heart of the soap – no-nonsense characters keeping their homes (and men) in check. In the Salford of 1962, there wasn't much in the way to lighten the household chores – from *stoning the step* to hanging out the washing.

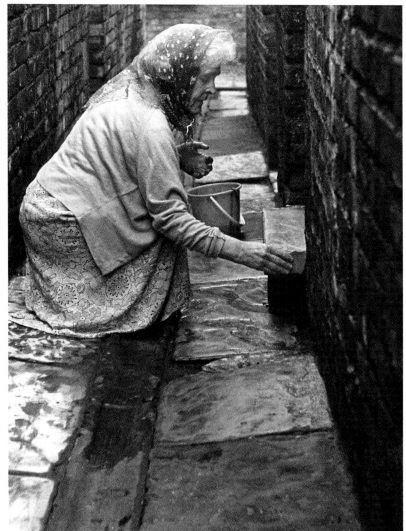

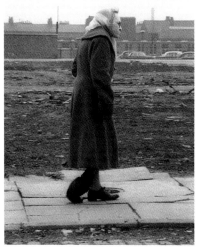

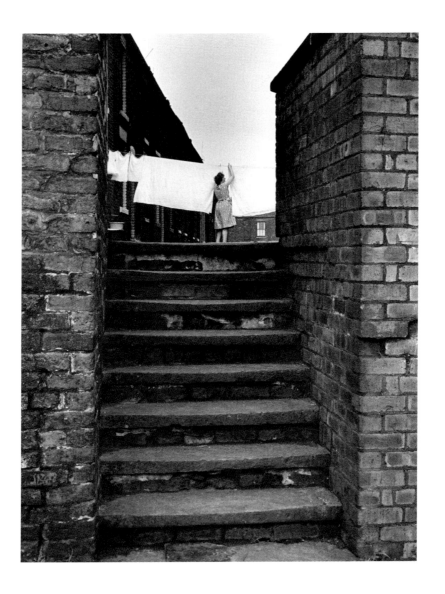

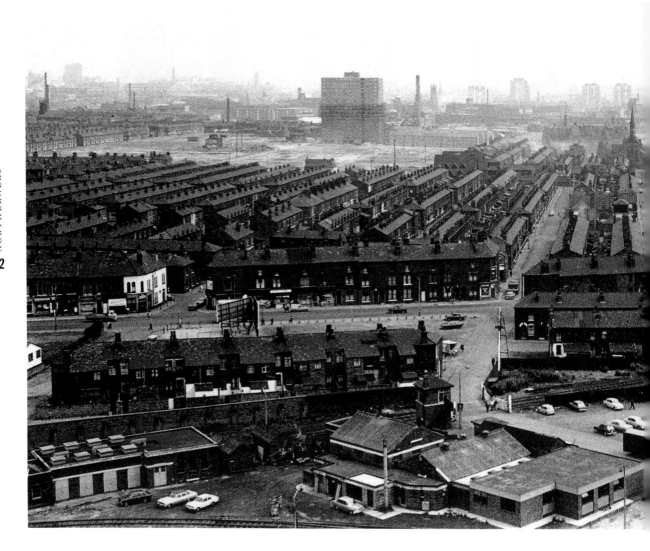

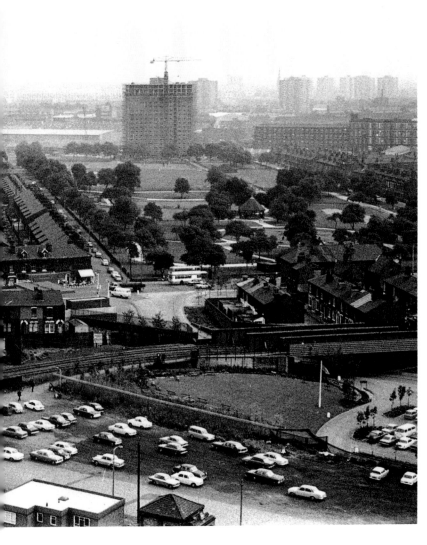

A panoramic view across Salford taken from the top of the old grain tower at the docks – looking down at the back-to-back houses, 1971.

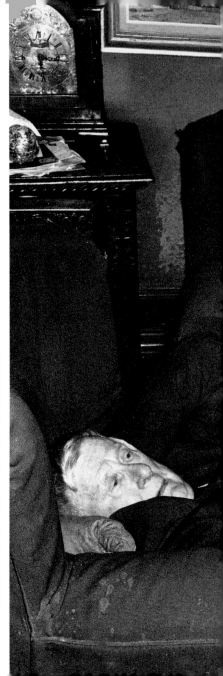

L.S. LOWRY AT HOME

In Lowry's own words, 'the best portraits I've ever had, lad'. Months of pestering and eventually having to butter up his cleaner paid off when I was invited to L.S. Lowry's Mottram-in-Longdendale home in 1968 – an honour rarely afforded to anyone by one of England's finest painters. Stacks of unopened post and piles of sketches littered the home as I snapped away.

Lowry wasn't pleased when I caught him smiling – so I asked Lowry how he'd like to be photographed. 'I'll show you what I like doing best,' said Lowry, who then slumped in his comfy chair and nodded off. Lowry liked my photos so much he ordered multiple copies for himself. His paintings can now fetch several millions of pounds. Not bad for the former debt collector.

OVERLEAF, RIGHT Something straight out of a Lowry painting – a scene from a school playground in Failsworth set against a ruined mill, 1973.

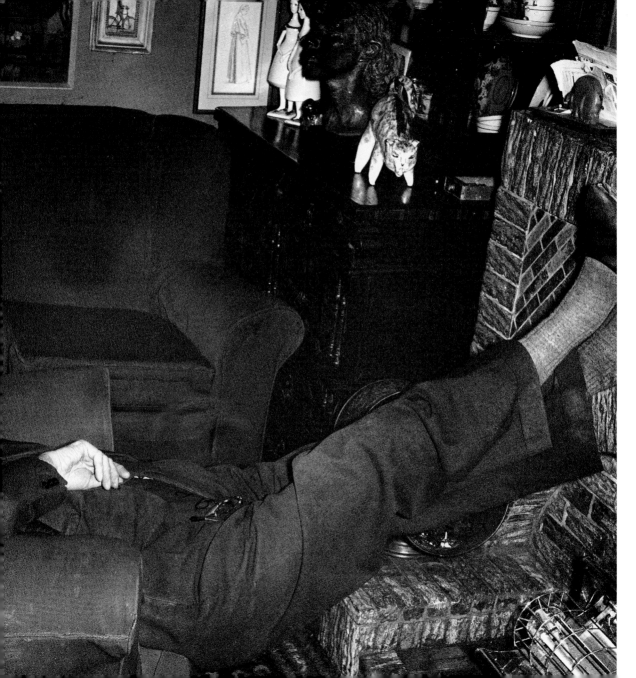

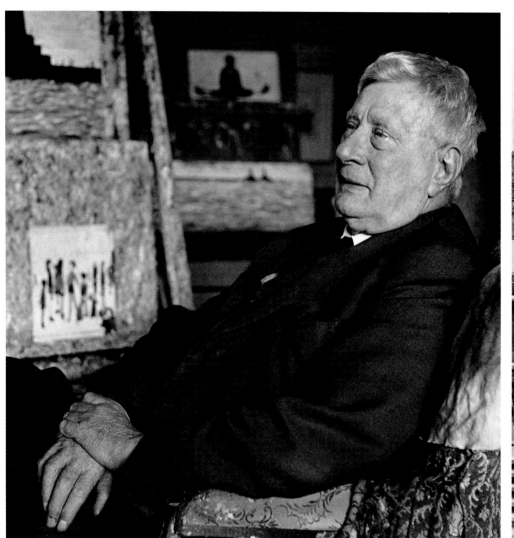

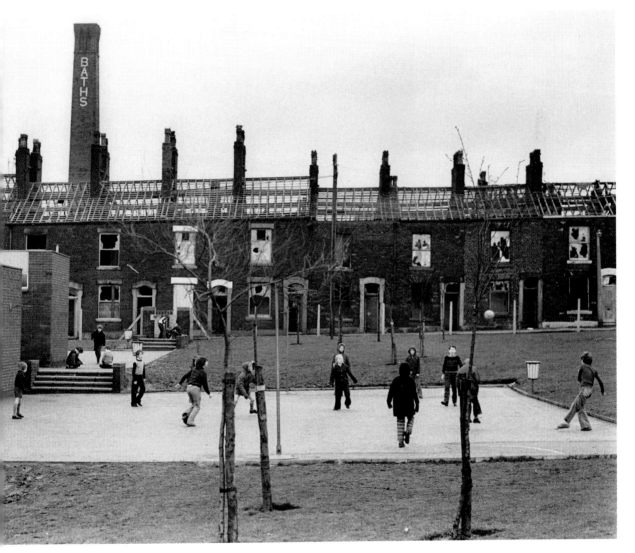

Yorkshire playwright Alan Bennett heads back to school to take questions on his play, *History Boys*, in 2006, to mark the release of the film version, which featured the original stage cast.

RIGHT Wigan-born artist and contemporary of Lowry, Theodore Major. Like Lowry, he was an uncompromising Northerner – refusing to sell his paintings and storing them in the next-door house. Critic John Berger said that Major's 'canvases deserve to rank among the best English paintings of our time'.

Two of the artistic alumni of Manchester Grammar
School: Academy Award-winning actor Sir Ben Kingsley,
1991 – and (RIGHT) leading film and theatre director
Sir Nicholas Hytner, 1991.

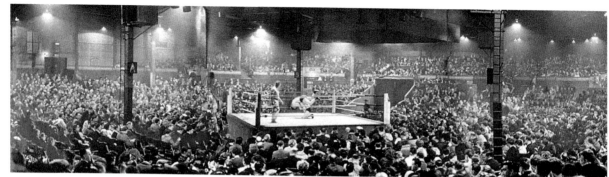

A DIFFERENT KIND OF THEATRE

Saturday night wrestling at Belle Vue in Manchester, 1959. Thousands packed the main hall every week to watch bouts. The front row was lined with some no-nonsense Nora Batty types who used to hit the wrestlers with their handbags if they burst through the ropes.

OVERLEAF The mighty Shirley Crabtree (later known as Big Daddy) sporting his trademark 64-inch chest and top hat, 1980.

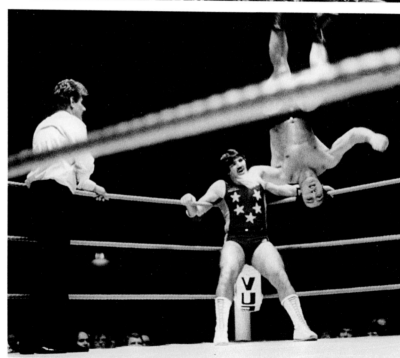

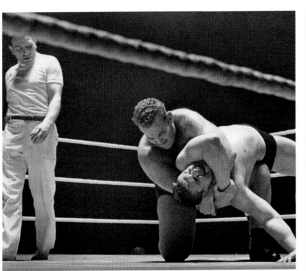
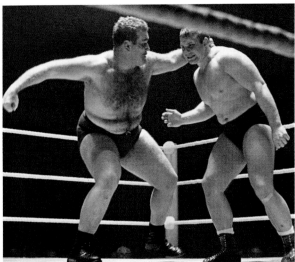

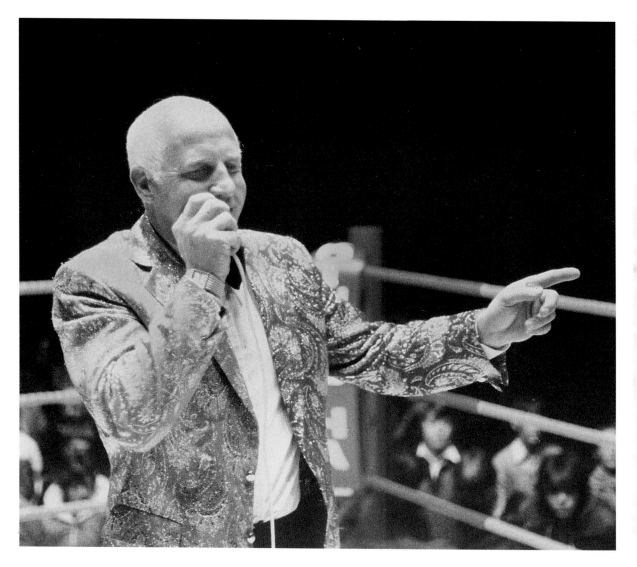

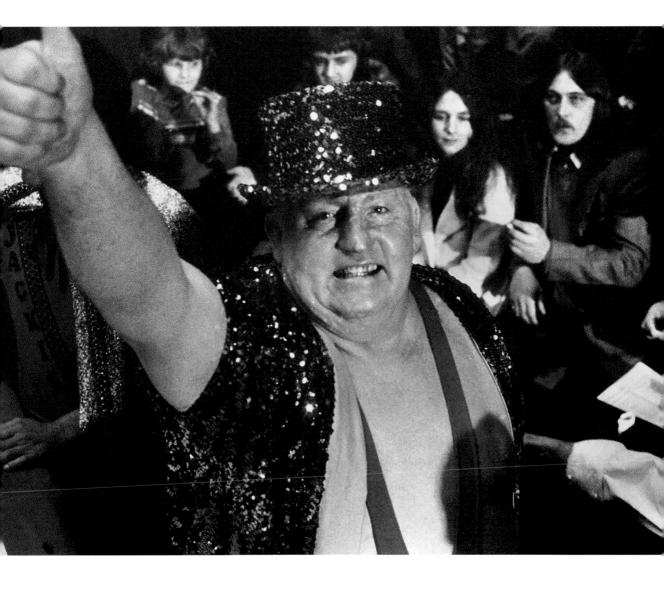

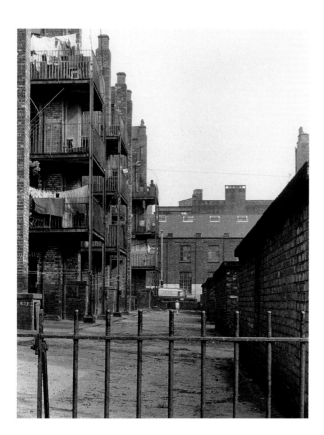

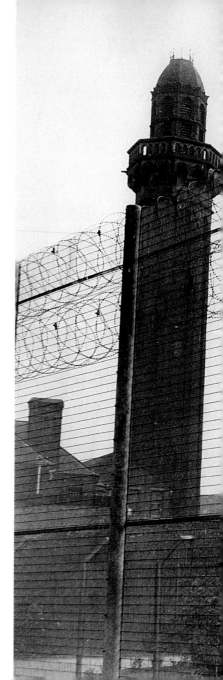

STRANGEWAYS HERE WE COME

The slums around Strangeways and the imposing Victorian jail
in 1971. The prison was the scene of Britain's longest prison riot
in 1990 (which lasted 25 days). Renamed in the 1990s, it remains
a high-security men's prison.

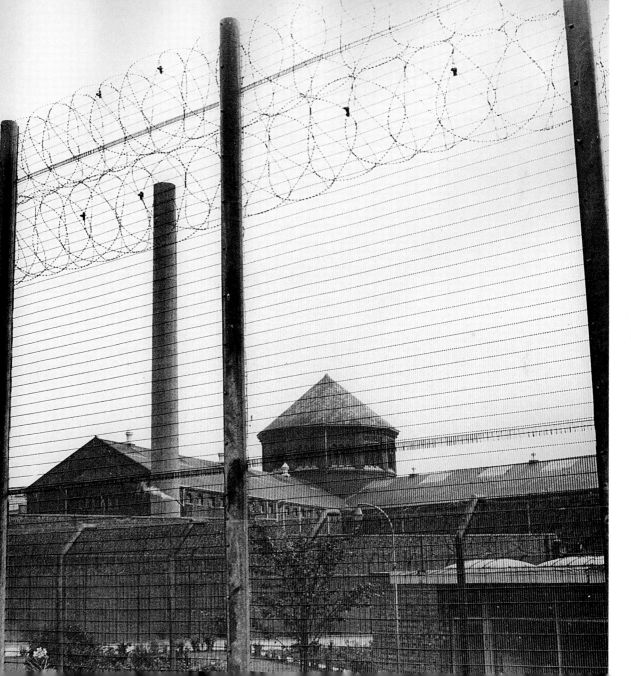

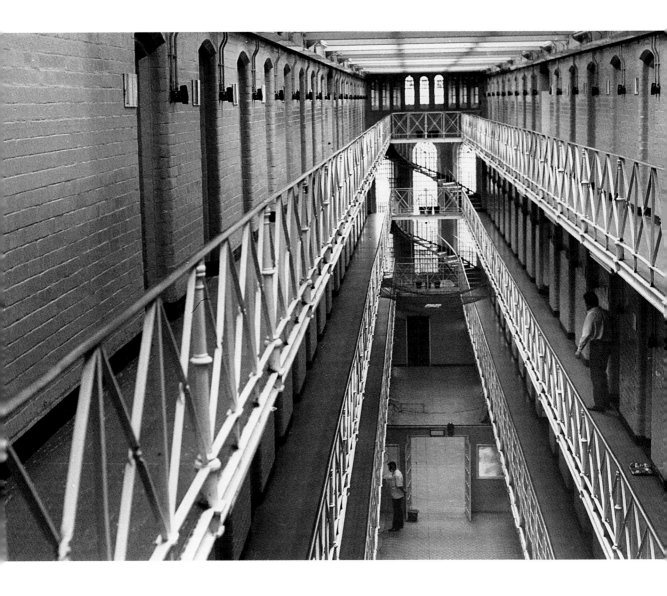

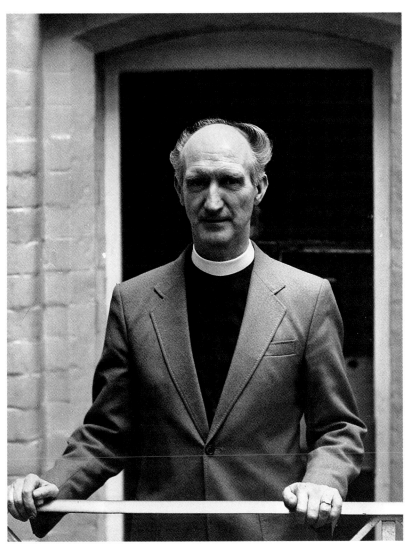

LEFT Inside the jail in 1983, with the chaplain Reverend Noel Proctor. It was in his chapel during a service that the ringleaders launched the riot, grabbing a microphone from the chaplain's hand.

ST. JOSEPH'S HOSPITAL

A portrait of St. Joseph's Hospital in Manchester – where nuns cared for the mainly geriatric patients, 1964. There was a quiet, dignified atmosphere. For many people, this was going to be their last place on earth. A chapel attached to the hospital allowed the nuns to pray during the day.

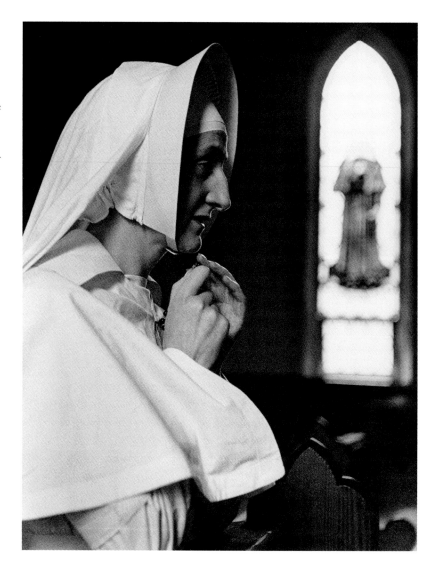

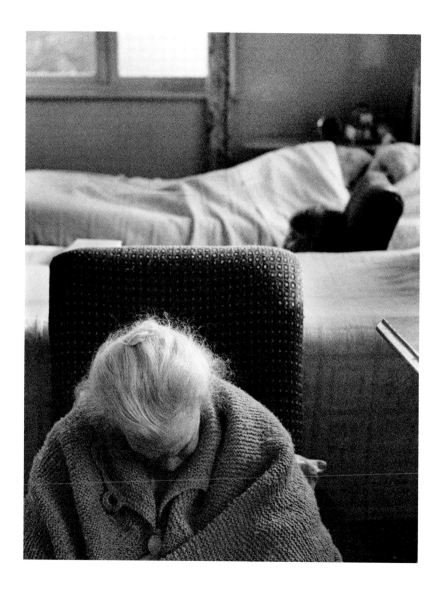

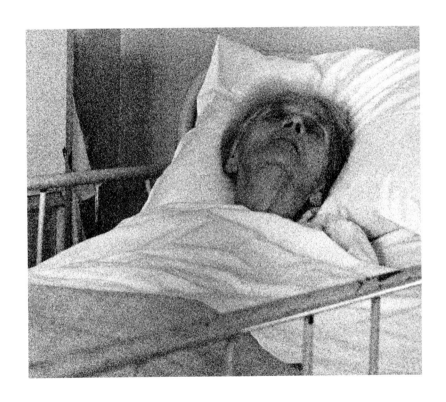

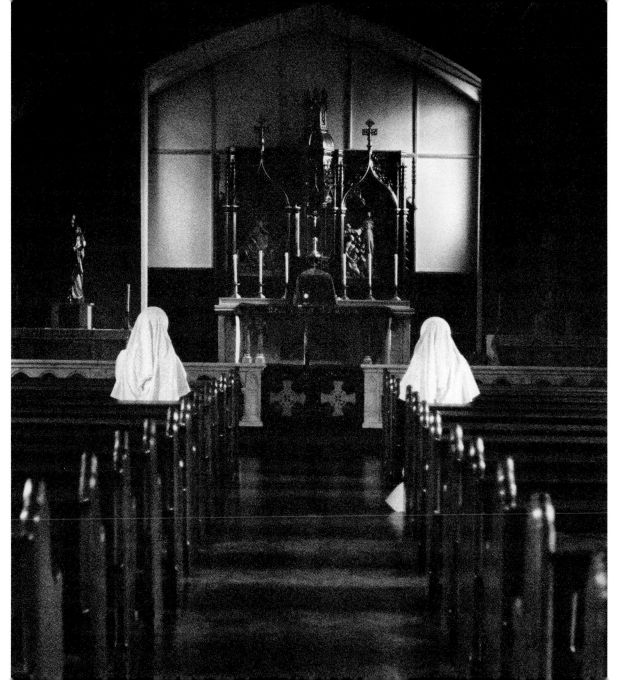

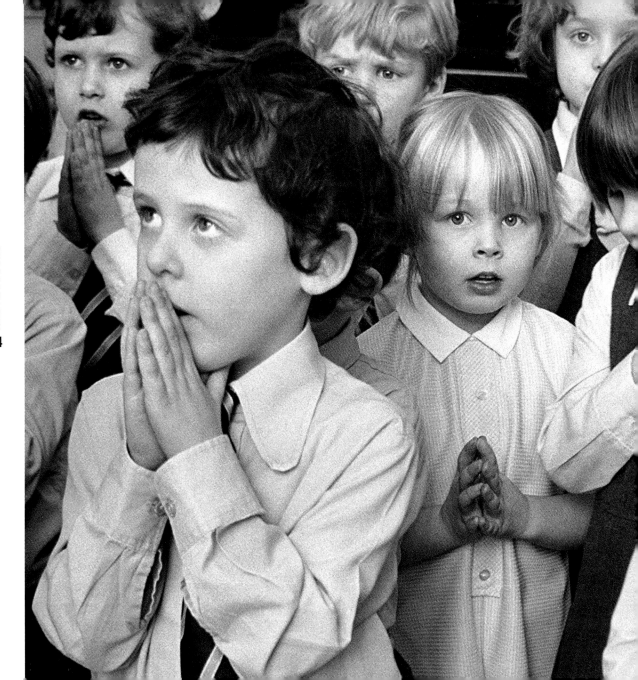

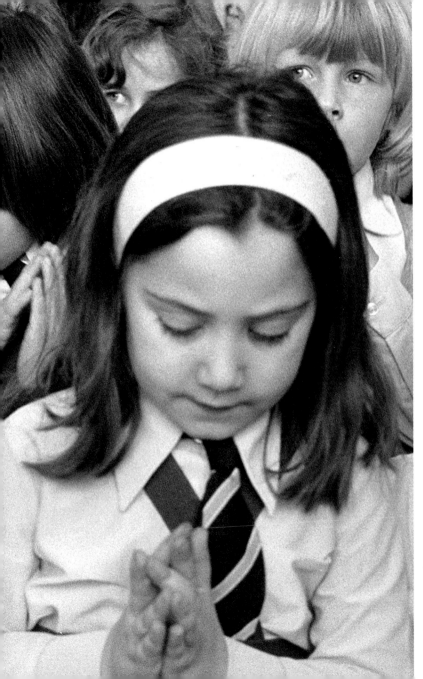

Morning prayers at Oaklands
Preparatory School, Chorlton,
in 1980.

ARISE, MAINE ROAD

Beneath an advertising board for Savill's Pies, the American Evangelist Billy Graham preaches at Manchester City's old Maine Road stadium in 1961. It wasn't a full house, but there was a decent crowd. At the time Graham was embroiled in fighting racial segregation in America.

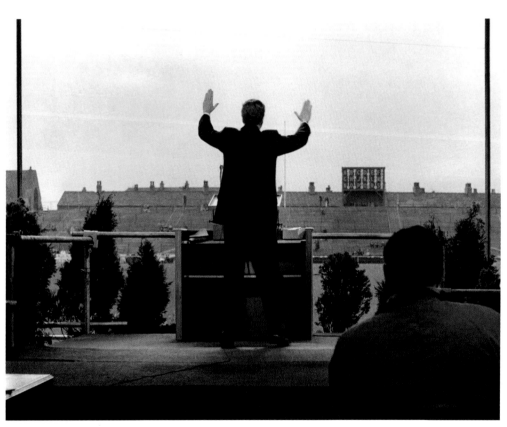

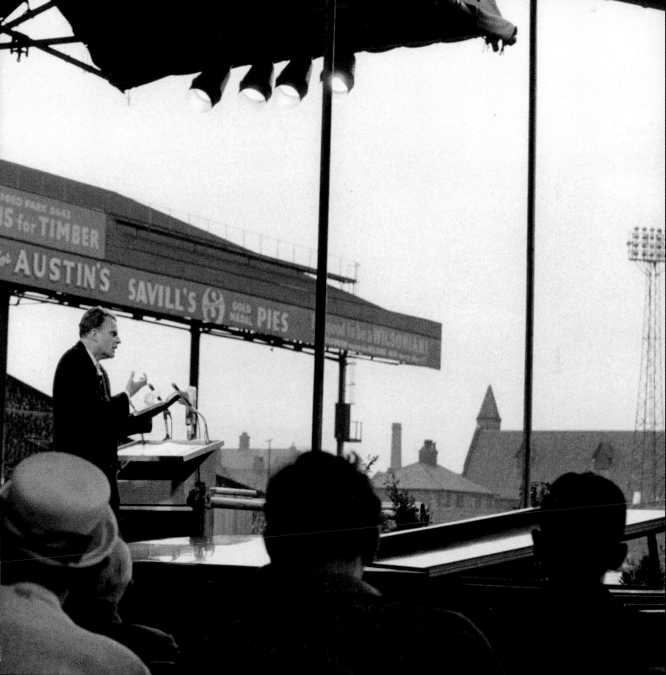

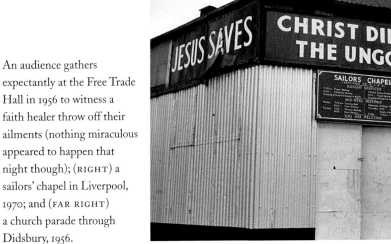

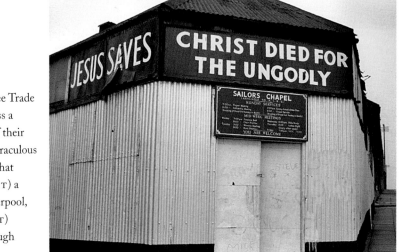

An audience gathers expectantly at the Free Trade Hall in 1956 to witness a faith healer throw off their ailments (nothing miraculous appeared to happen that night though); (RIGHT) a sailors' chapel in Liverpool, 1970; and (FAR RIGHT) a church parade through Didsbury, 1956.

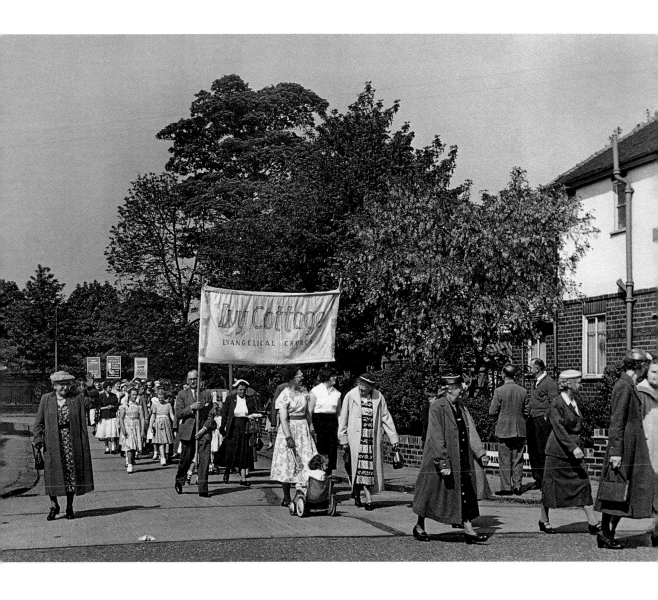

ANOTHER KIND OF RELIGION

The greatest era for the blue half of Manchester.

RIGHT Legendary manager Joe Mercer sits in the City boardroom with his chairman and the 1969 FA Cup. The year before, City had won the league – and the next year they'd take the European Cup Winners' Cup and the League Cup.

BELOW After I had photographed Joe Mercer with the cup, we were standing on Maine Road when one of the Manchester City secretaries walked past. Without hesitating, Joe just whisked her up into his arms.

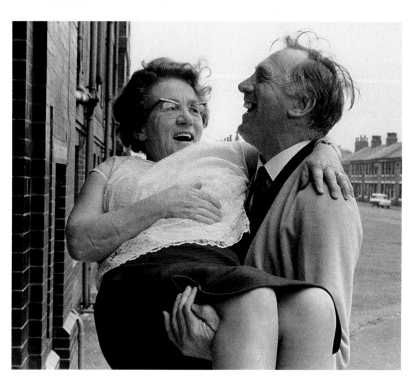

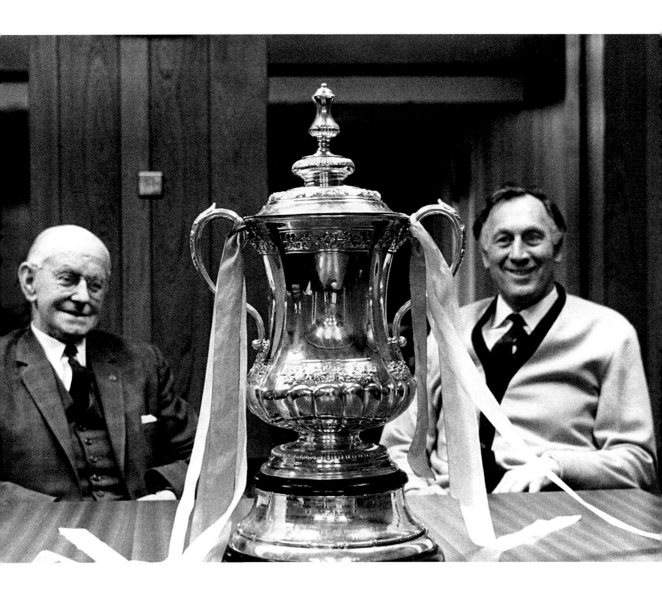

'Big Mal', Manchester City manager Malcolm Allison, swaps his trademark fedora and cigar for a local cat during a pre-season photo shoot, 1979.

RIGHT Legendary goalkeeper Frank Swift and his wife, snapped on his way out of the ground in 1947 by me – a schoolboy at the time, using a basic box camera. Such was Swift's status that he was the only player other than the captain allowed a car. After retiring, Swift moved into journalism – and tragically died during the Munich air crash after reporting on United's game.

FAR RIGHT Mike Summerbee rises to the ball, as City take on Newcastle United, 1969.

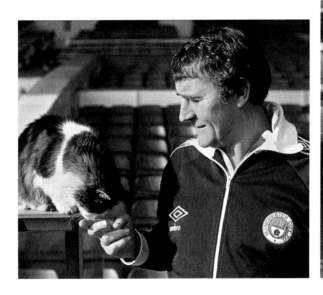

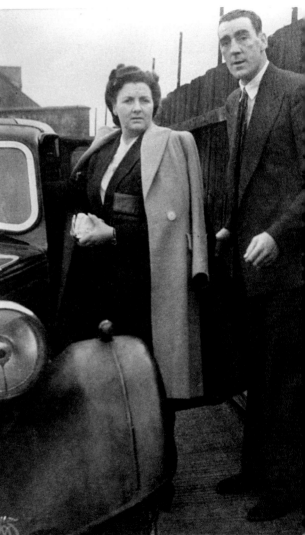

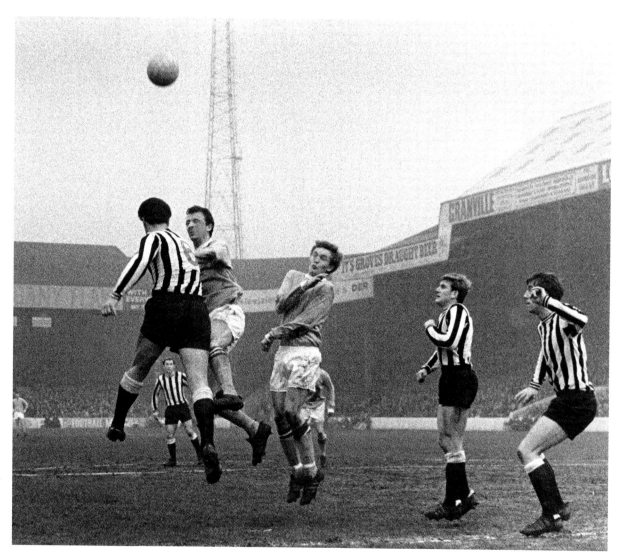

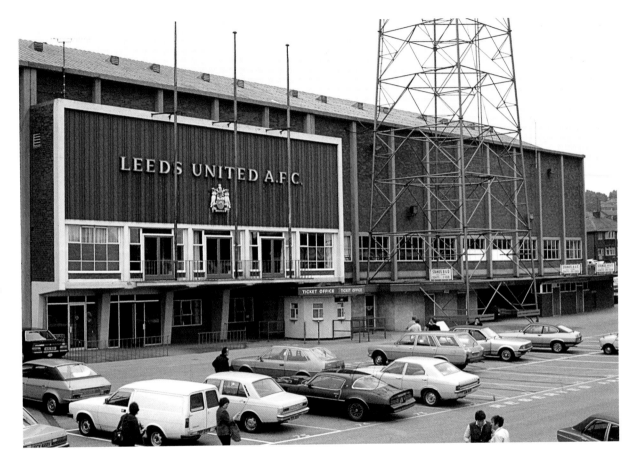

Elland Road, the home of Leeds United, in 1979. The glory days under Don Revie had come to an end, and the club was slipping towards relegation by 1982. The players' cars parked outside the ground attest to a time when football was still a game of the people.

RIGHT One of the true legends of British football, Brian Clough – who himself had a 44-day spell in charge at Elland Road. With former assistant manager Peter Taylor alongside him in the dugout, Clough is pictured at Maine Road in 1980 – and (OVERLEAF) in 1978.

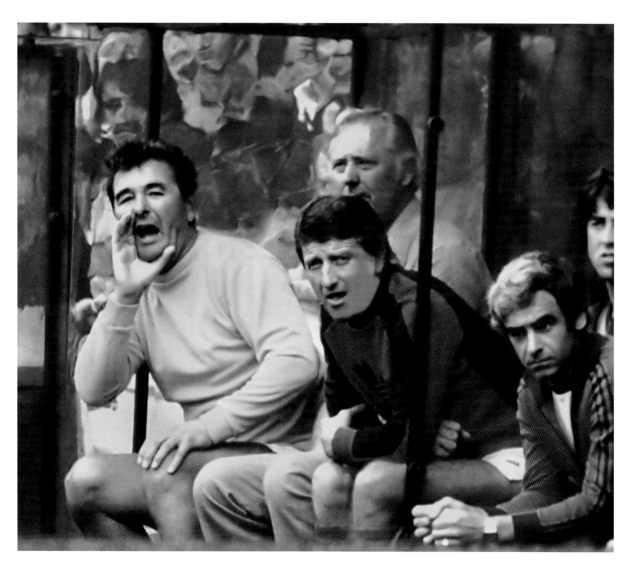

Bill Shankly – the greatest name in Liverpool's illustrious history. Winner at Anfield of three League titles, two FA Cups and a UEFA Cup. The manager who revolutionised Liverpool. And a difficult man to photograph. My attempts to snap him at Liverpool – including knocking on the manager's door – were always sent packing. But I managed to grab a retired Shankly during half time at a Wrexham game, 1978.

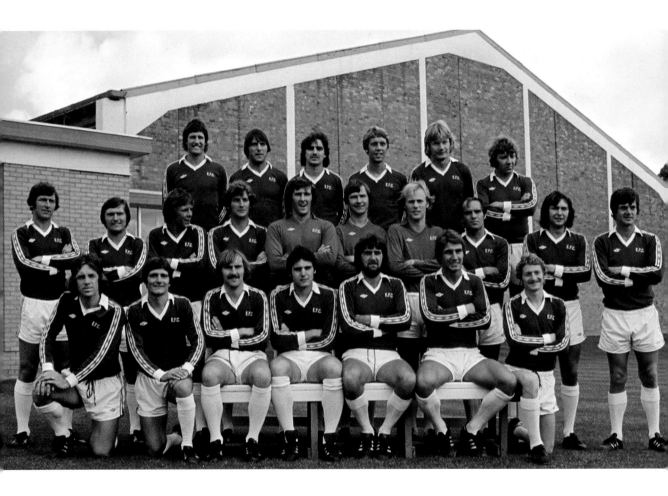

The Everton team line up ahead of the 1977/8 season. It was a bleak period for English football at the time, having failed to qualify for the second World Cup Finals in a row – so a national newspaper offered (a then whopping) £10,000 to anyone who could score 30 league goals that season. Everton's Bob Latchford duly obliged, won the cash and propelled his team into third place.

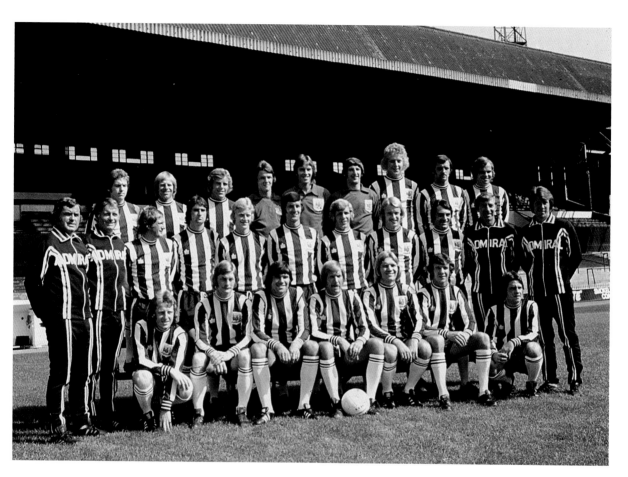

The smiles before a giant footballing fall. The Sheffield United
team pictured in 1975, when they'd just finished sixth. By 1981
they'd plummeted to the old Fourth Division. Still, at least in 1975
cricket upped sticks – leaving Bramall Lane to football alone.

THE ORIGINAL RED DEVIL

Manchester United manager Matt Busby back at work in his plain Old Trafford office after leading United to victory in the 1968 European Cup. An extraordinary achievement coming only 10 years after the Munich air disaster which killed so many of the Busby Babes and badly injured Sir Matt himself. It was Sir Matt who coined the term 'Red Devils' to describe United.

Busby was softly spoken and down to earth. He just sat at his desk making calls and trying to work on the United team for the coming Saturday.

OVERLEAF The Stretford End at Old Trafford watch United, 1980.

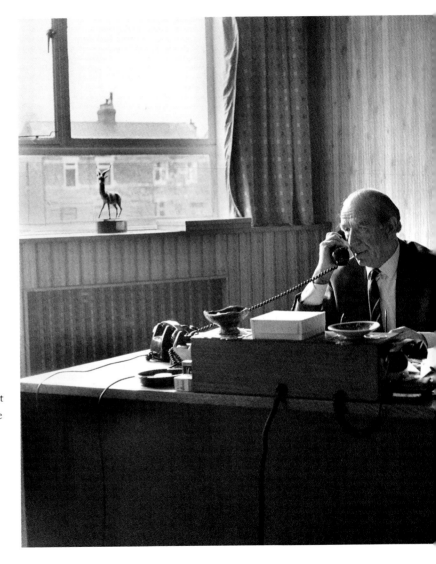

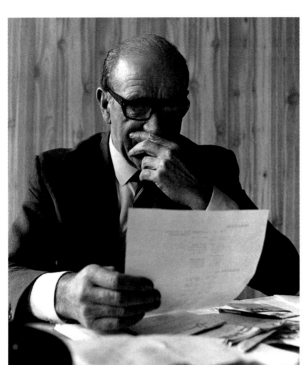

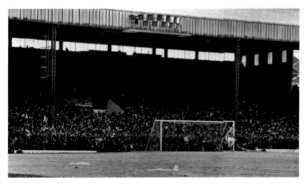

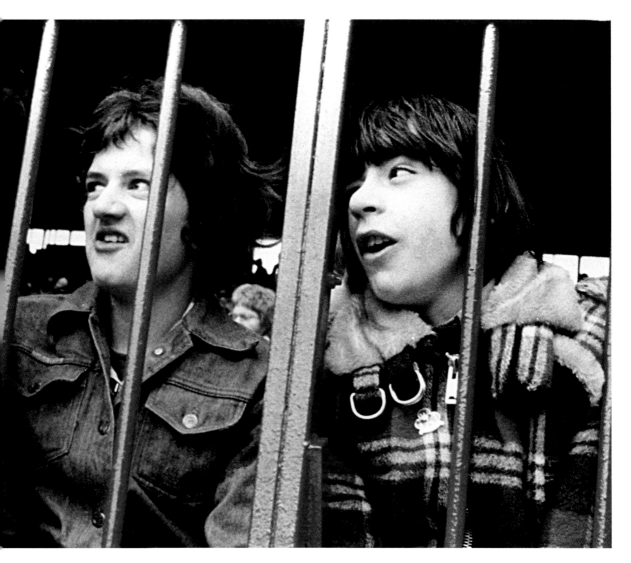

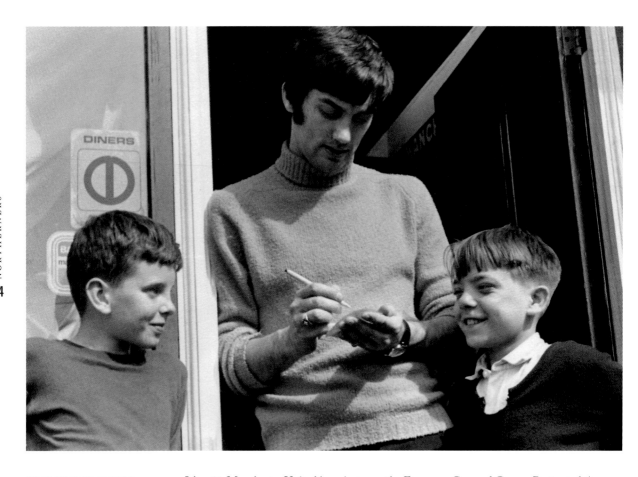

HONORARY NORTHERNER

It's 1968. Manchester United have just won the European Cup and George Best voted the European Footballer of the Year. The 22-year-old legend is at the height of his dizzying career. But young George has a menswear boutique in Manchester to run too. I found football's first superstar just hanging around outside his clothes shop – happily signing autographs for kids who sheepishly made the pilgrimage to George's store.

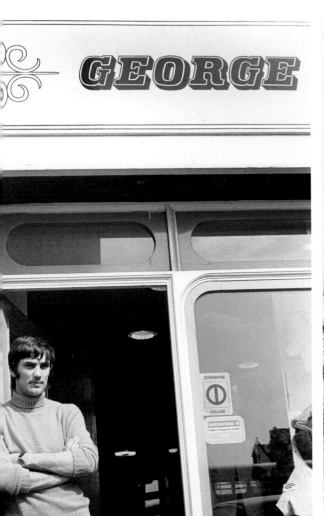
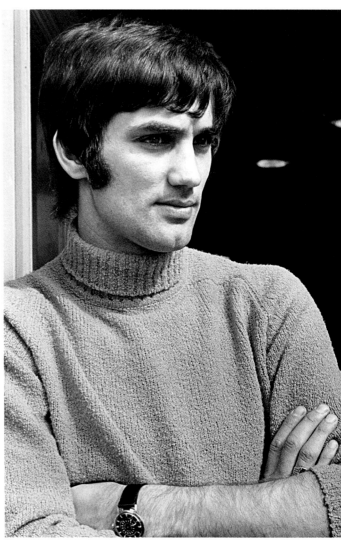

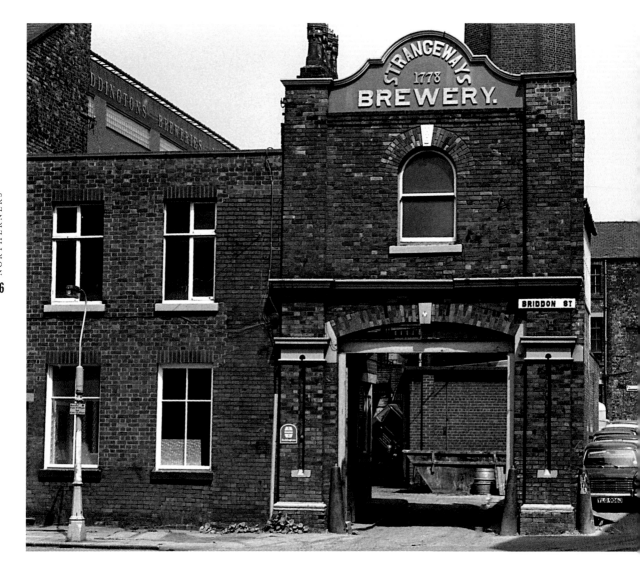

NORTHERN TRADITIONS

A stone's throw from the prison, the Boddingtons Ale brewery in Strangeways, 1974. A fixture in Manchester since 1778, beer was brewed on the Strangeways site until 2004 – the brewery was demolished three years after that.

BELOW Trombonist Ken 'Seven Pints' Parkinson takes on a yard of ale in 1956. The first thing Ken would shout when the jazz band – for which I drummed – arrived at a venue for a gig was always 'Seven pints!'

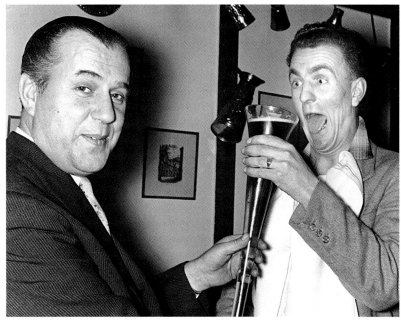

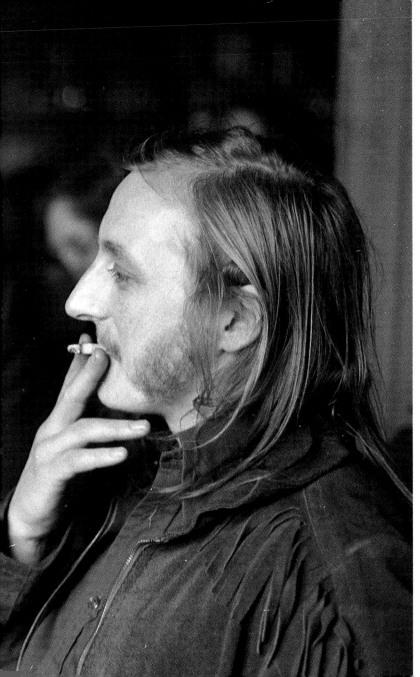

Enjoying a pint in Bacup, on Easter Sunday – a day when folk dancers known as 'Nutters' invoke ancient traditions, blacken-up and dance around the town's boundaries, 1980.

Black puddings being made in a back room in Rawtenstall and sold at Bury market, 1980. An irresistible blend of pig's blood and fat.

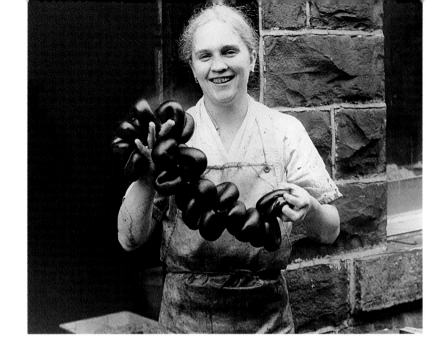

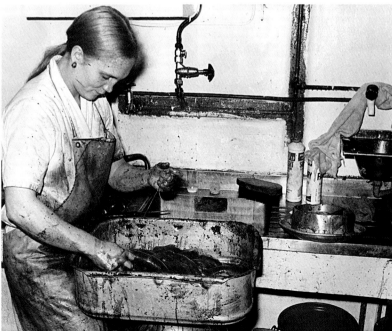

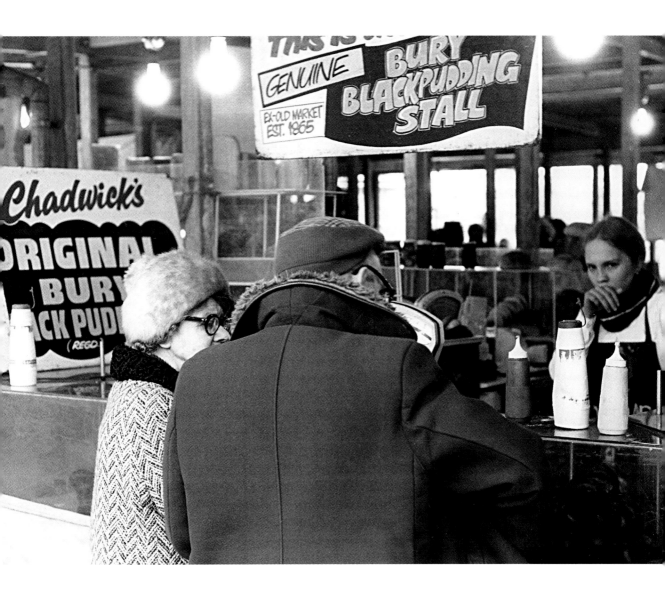

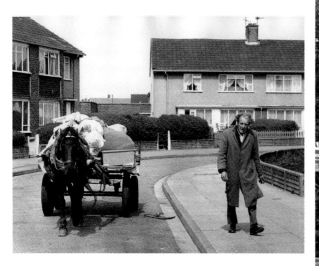

Rag-and-bone men in Liverpool, 1973, and Audenshaw, 1980. A rare sight on the streets today.

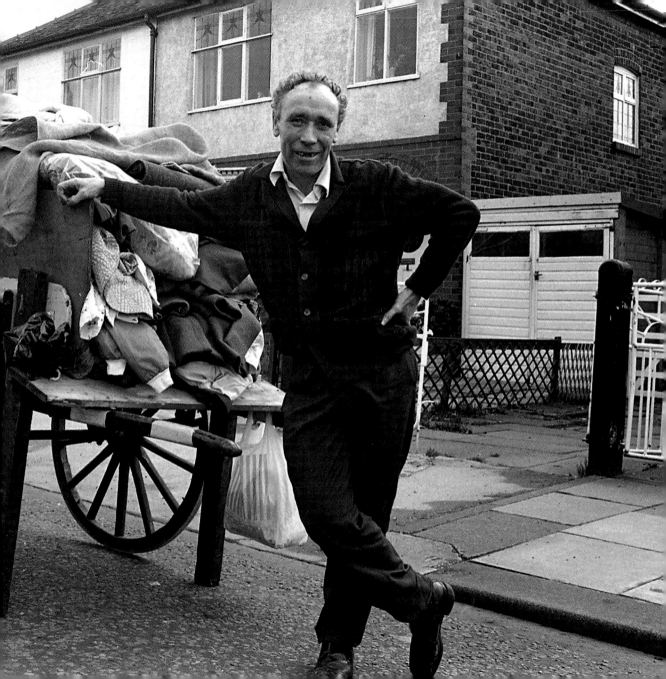

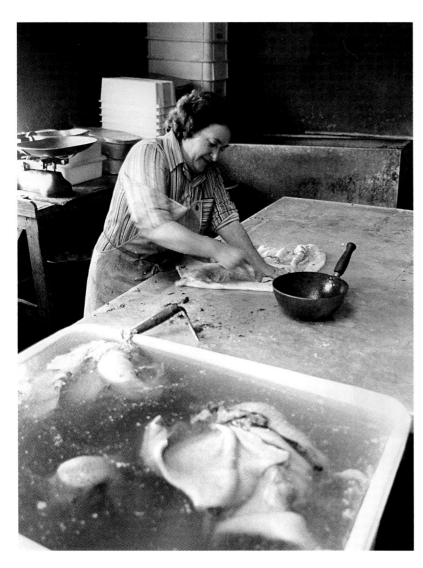

Gurning, as part of the Saddleworth
Rushcart festival, where the ugliest face
pulled wins, 1980.

RIGHT Tripe dressing in a back kitchen
in Rawtenstall, 1980.

HARD GRAFT

There's nothing like a clog to conjure up a Northern stereotype. Sturdy and cheap, they initially became all the rage in the mills and factories of industrialised Lancashire and Yorkshire. Here, a traditional clog-maker at work near Bury, 1980.

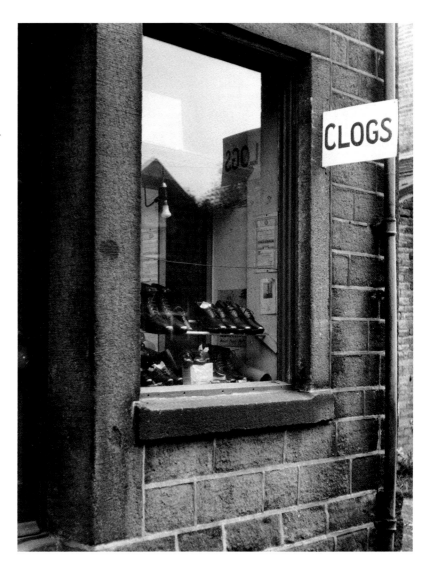

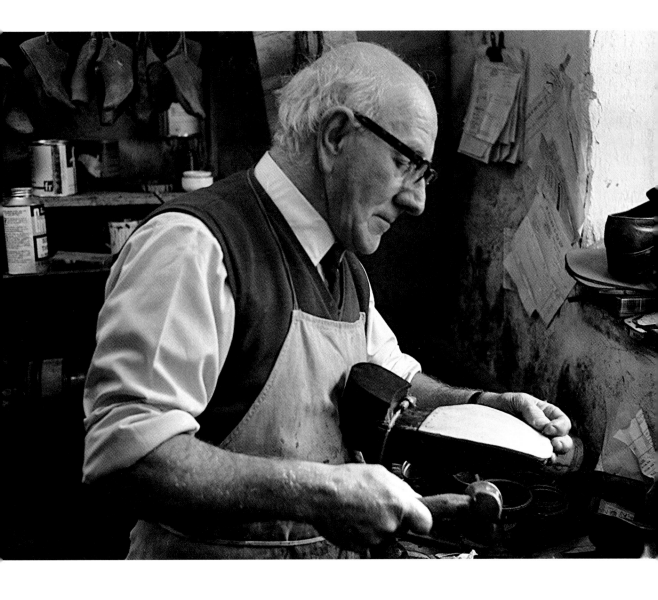

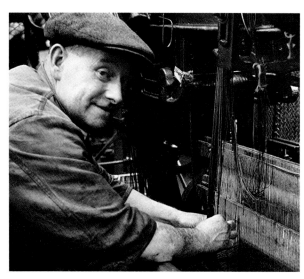

Arthur, the loom mechanic at the Kaye and
Stewarts mill in Huddersfield, 1954.

RIGHT Road-sweeping in Rawtenstall, 1980.

OVERLEAF Traditional hat manufacturers in
Failsworth in 1981 – a town which once housed
the biggest hat-makers in Europe and still has
some modern hat manufacturing.

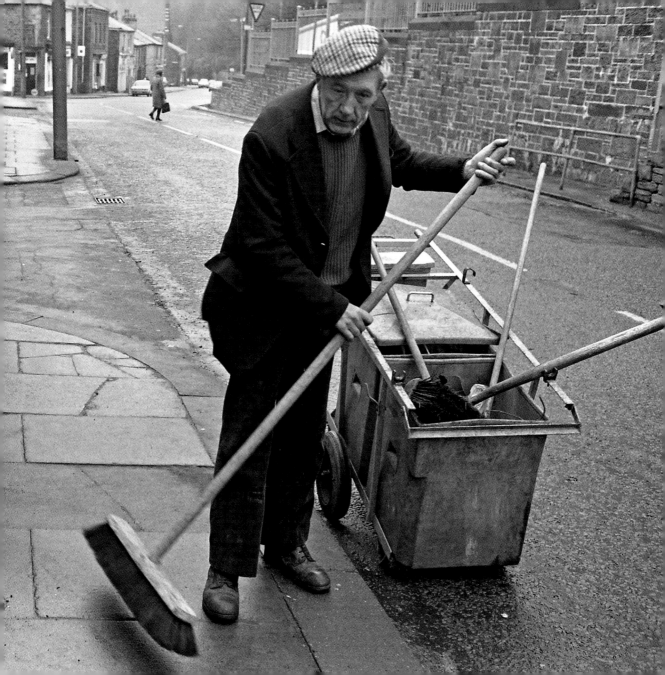

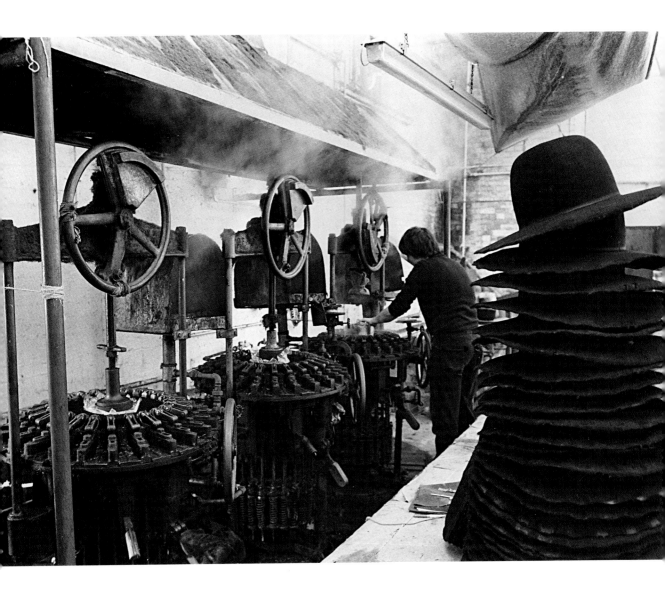

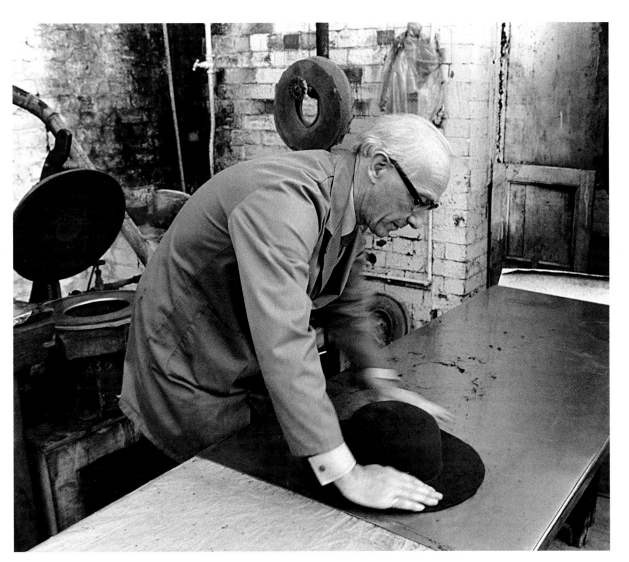

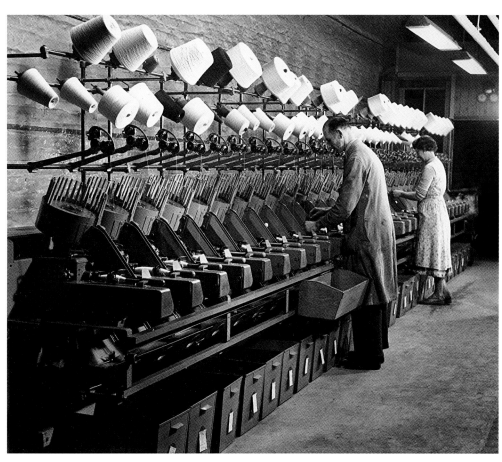

A mill just outside Bradford, where I was assistant manager at the time in 1954. A noisy place where most of the jobs were manually intensive; it's not a period I've come to romanticise.

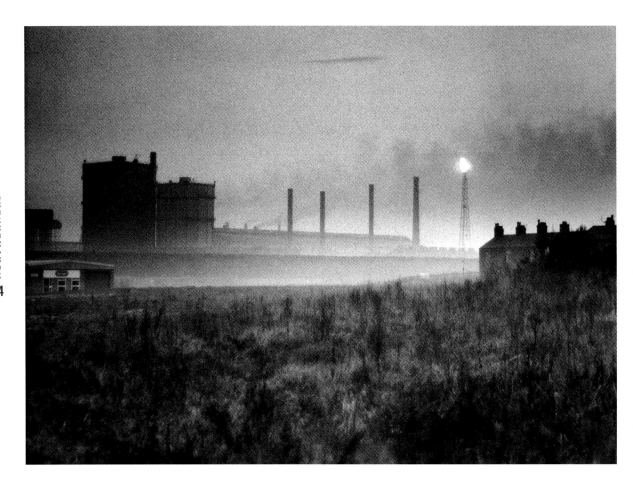

Steel works in Irlam, 1970, which by the end of the decade had ceased production.

RIGHT Steeplejack-turned-television presenter Fred Dibnah pictured in front of
a Stockport chimney, 2000 – and (FAR RIGHT) gasworks in Manchester, 1969.

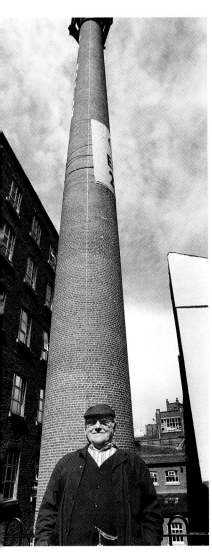

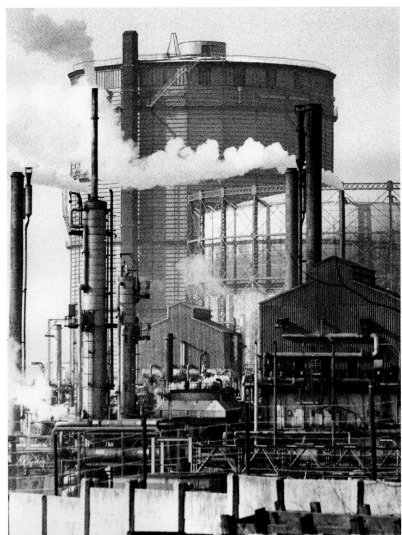

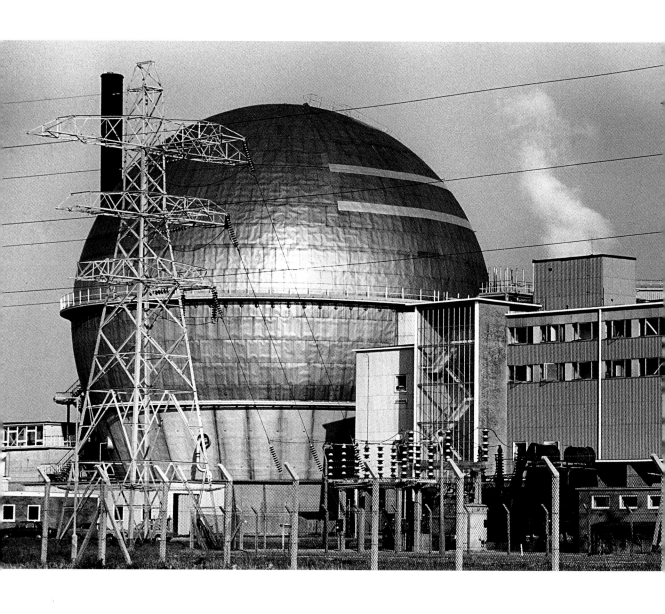

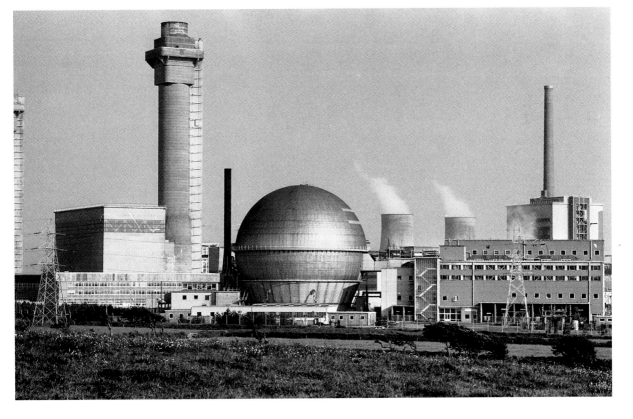

The iconic golfball-shaped reactor at the Sellafield (formerly Windscale) nuclear processing and power plant in Cumbria, 1977. Built in the 1940s, it's been dogged by controversy over the years – the reactor has been closed but nuclear waste is still reprocessed at Sellafield.

SHIP SHAPE

Workers stream out of the Wallsend
Shipyard in 1982, which at the time
had been nationalised. After a long
history turning out battleships and
ocean liners, the yard closed in 2007.

RIGHT Construction at Swan
Hunter, 1984.

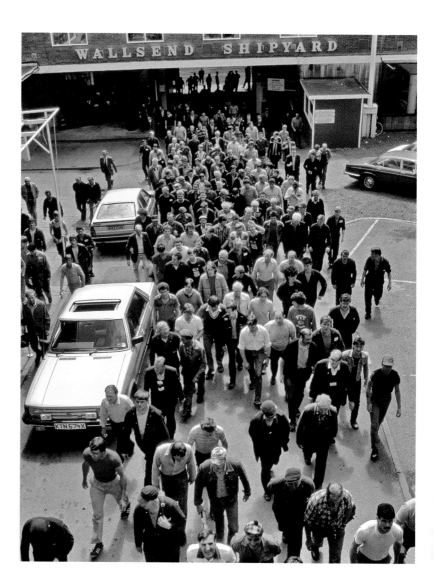

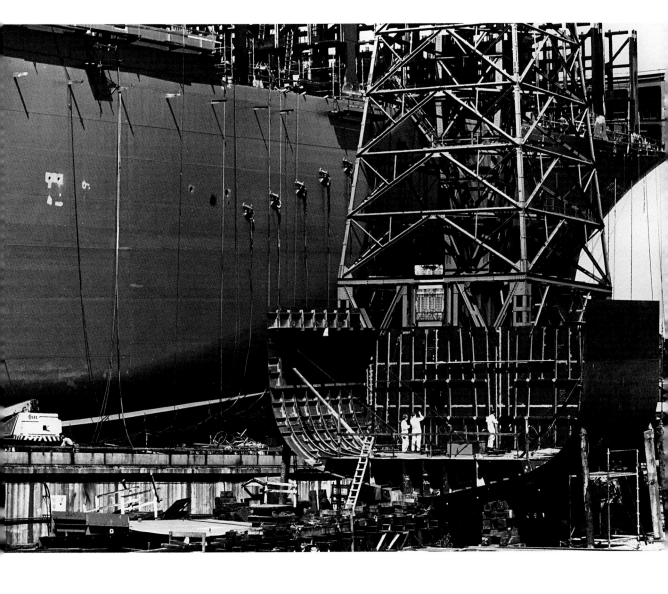

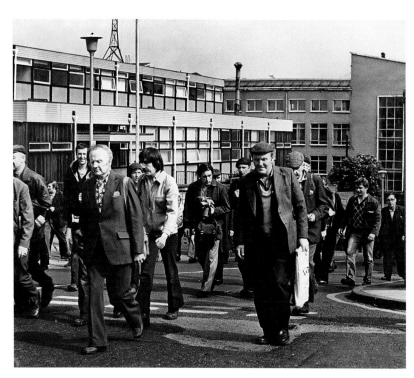

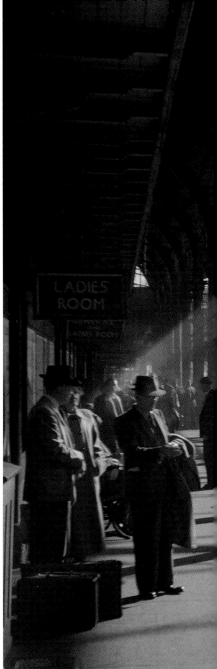

More shipyard workers clocking off from Wallsend – and Newcastle railway station, 1953.

OVERLEAF The Ford assembly line at Halewood in 1985, and the site of British Leyland – which once held 40 per cent of the UK car market – in 1977, two years after being part-nationalised by the Government.

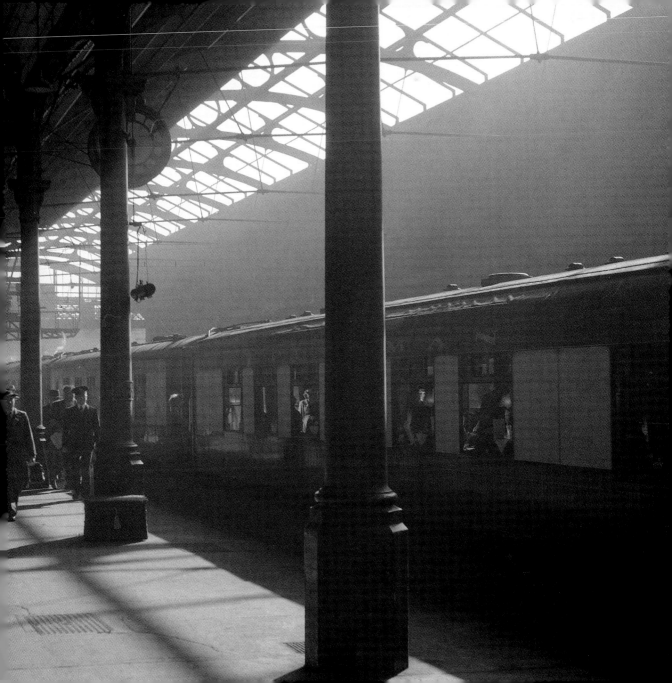

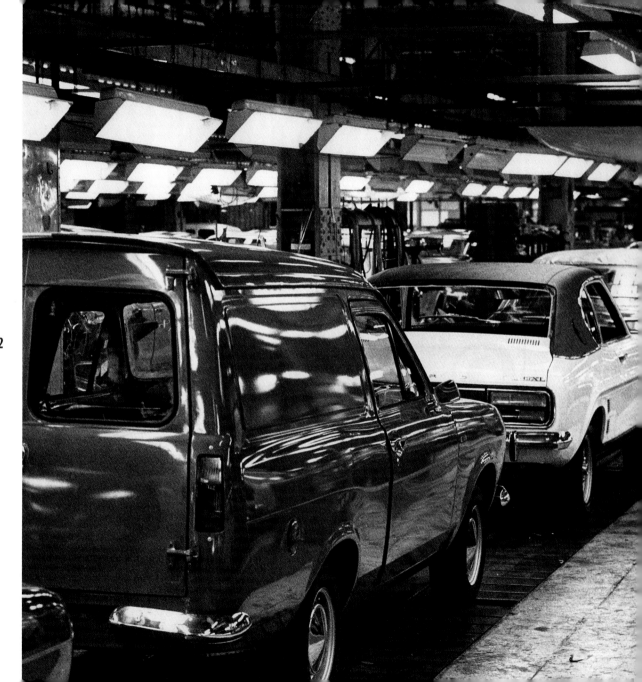

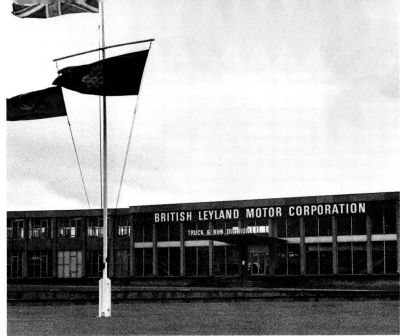

BRITISH LEYLAND MOTOR CORPORATION
TRUCK & BUS DIVISION

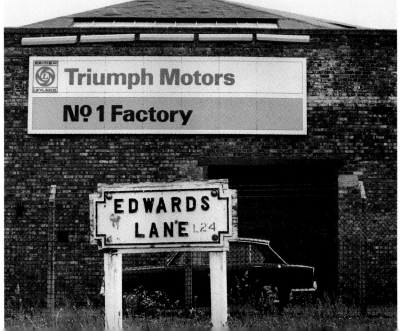

Triumph Motors
Nº 1 Factory

EDWARDS LANE L24

DEEP TROUBLE

The defining confrontation of the 1980s saw Margaret Thatcher's government face down the miners – which effectively sounded the death knell for the industry. The miners were led by gruff Yorkshireman Arthur Scargill – here pictured outside a Barnsley pit in 1983. A year before the mass strikes of 1984/5, I went down the pit at Bold Colliery in St. Helens.

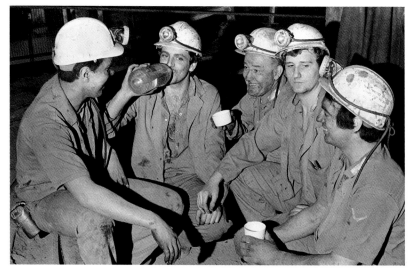

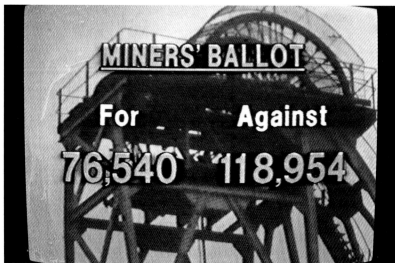

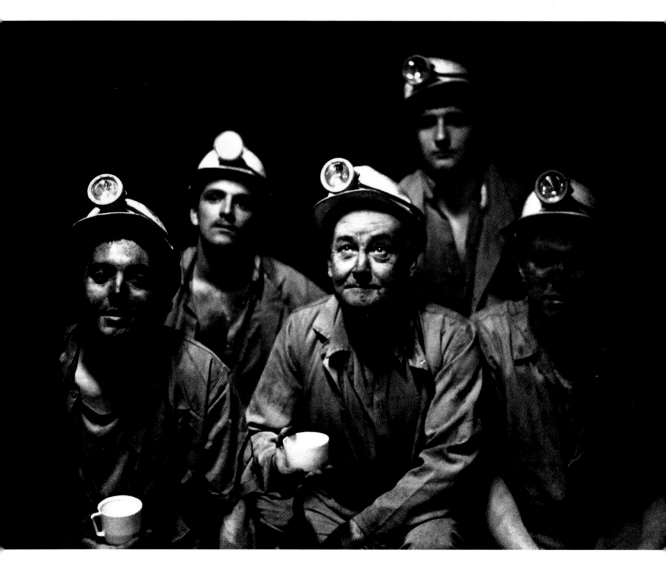

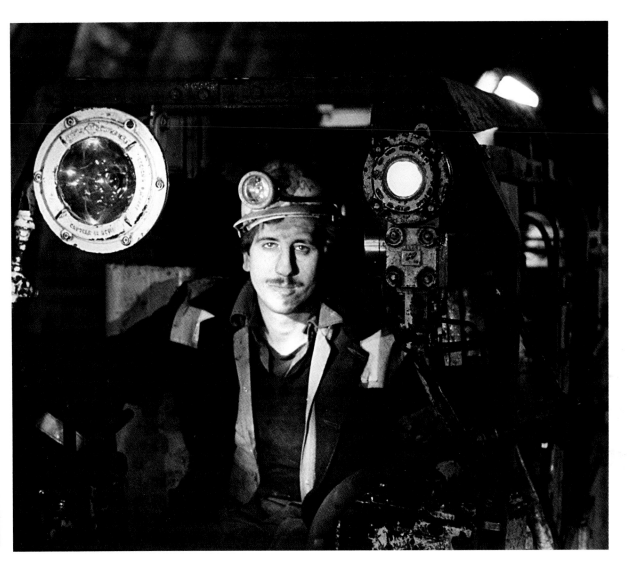

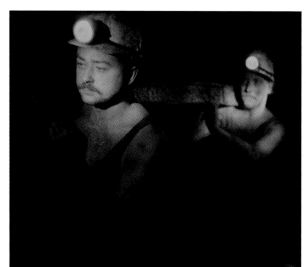

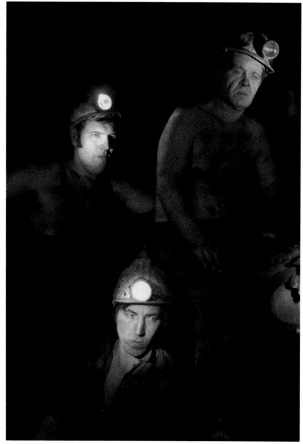

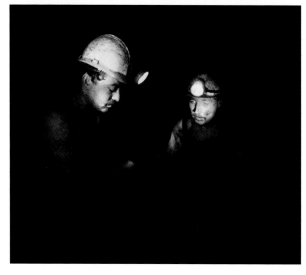

The mine was one of the area's biggest employers, but it was tough graft which at times could be treacherous. Over its 100 years, some 70 boys and men died working at the colliery, 1983.

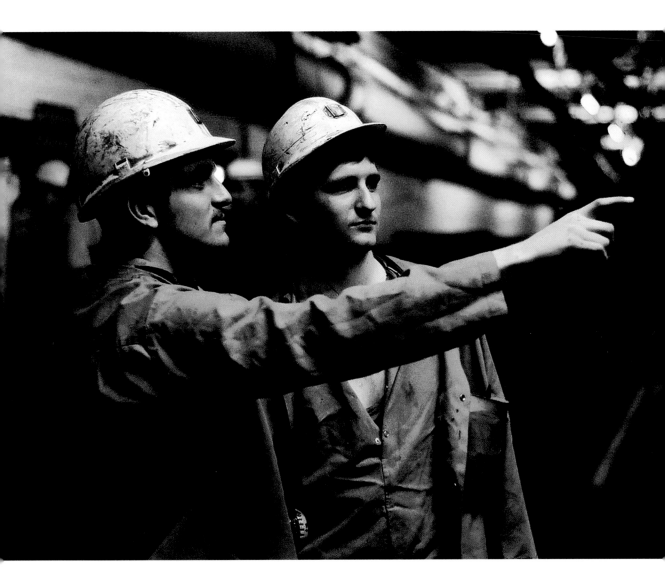

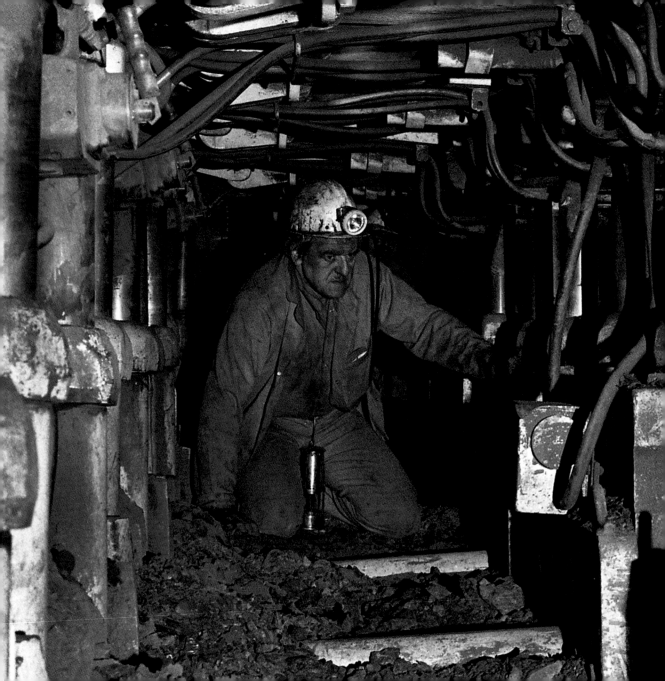

Heralded in the 1960s as the most
advanced mine in the country, by the
1980s Bold's output was declining
– dwindling reserves and outdated
technology were catching up. An
industry engrained in generations
of families was under threat.

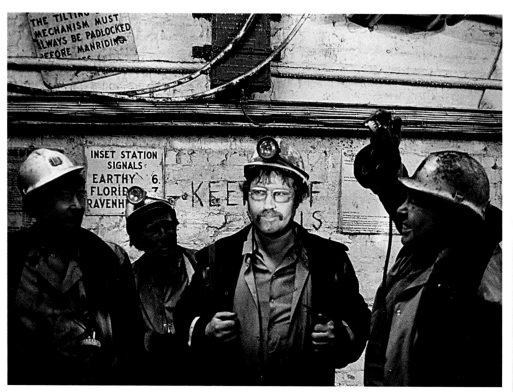

The colliery became the first Lancashire pit to join the national strike in 1984. The majority of the thousand miners remained on strike during the year of industrial action, which saw violent clashes at Bold. The mine was closed down in 1986.

RIGHT A derelict colliery at Astley Green, which has now been turned into a mining museum, 1972.

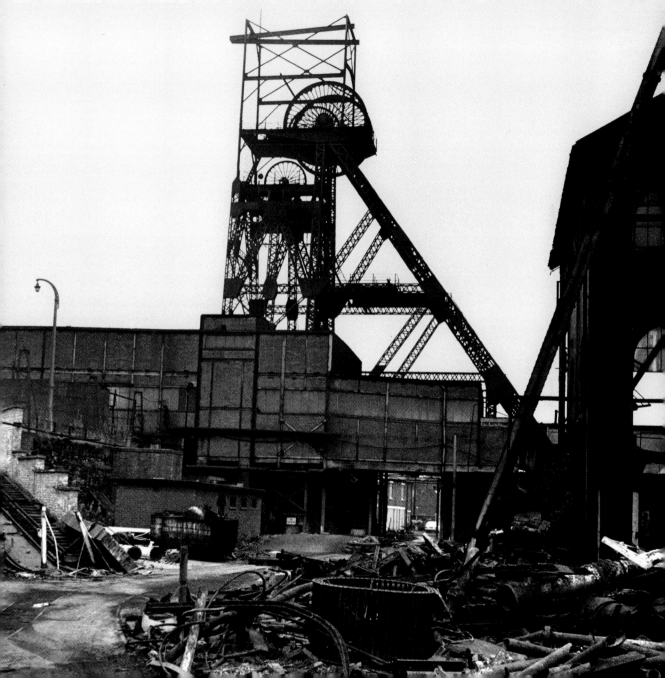

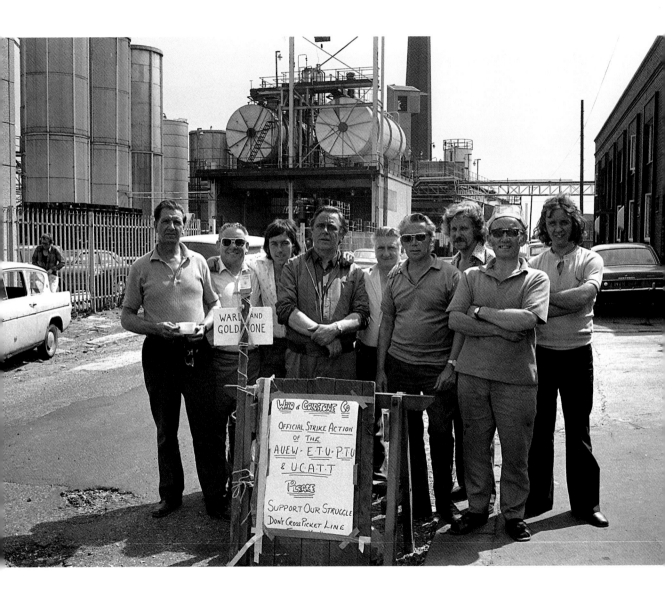

Industrial action – from a host of combined unions – outside electrical manufacturers Ward and Goldstone, 1975. And a scrapyard in Sunderland, 1968.

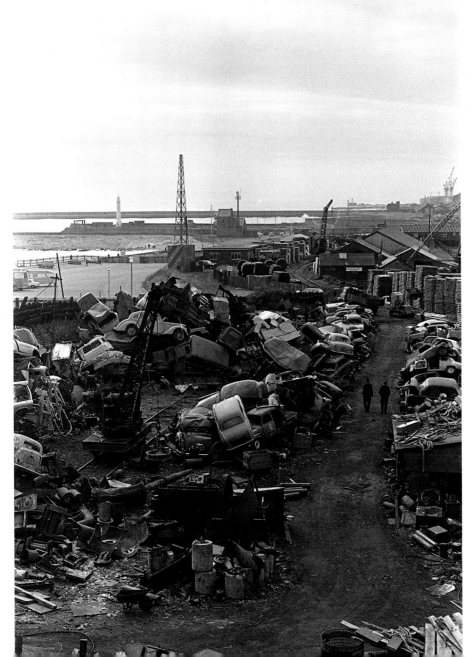

HOLD TIGHT

Who needed Alton Towers, when there was the
Belle Vue funfair for an adrenaline fix, in 1969?

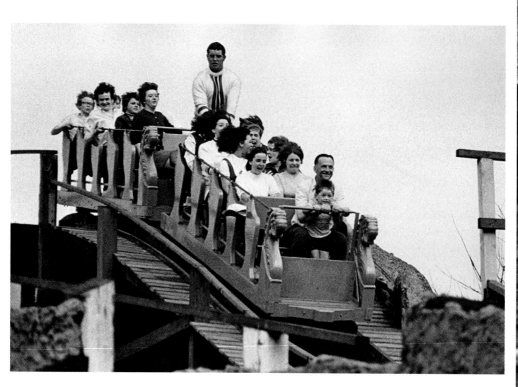

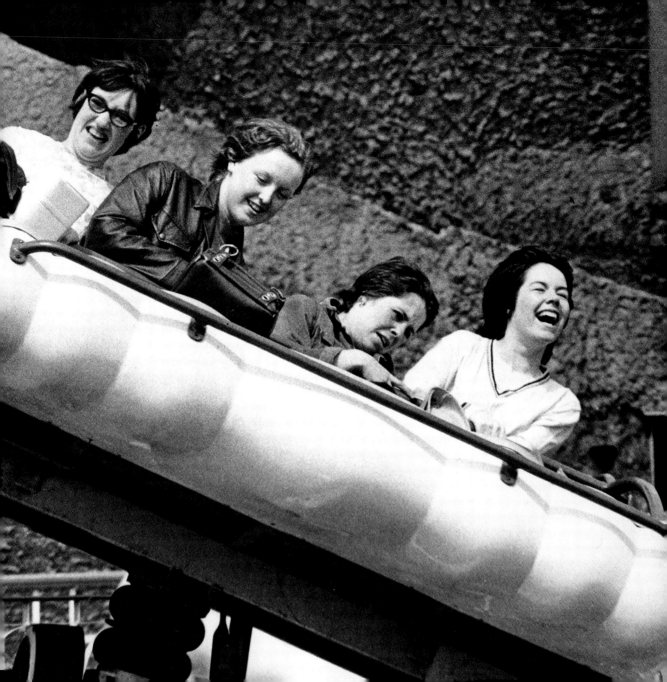

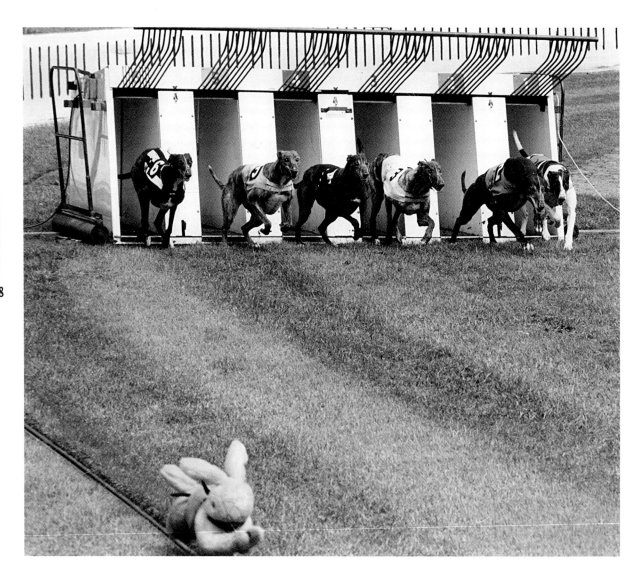

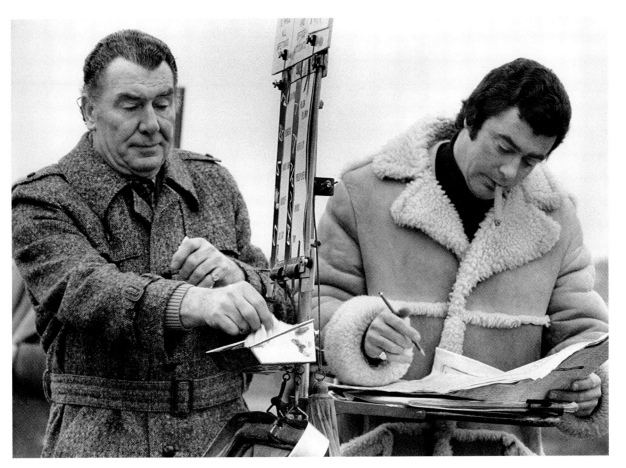

Greyhound racing in 1981 at White City – which was demolished shortly thereafter. In its heyday, the dog stadiums in Manchester could pull in more than 70 thousand punters a week.

RIGHT Bookmakers at Haydock Park Racecourse, 1980.

OVERLEAF Tackling the fence, 'the Chair', at the 1980 Grand National at Aintree.

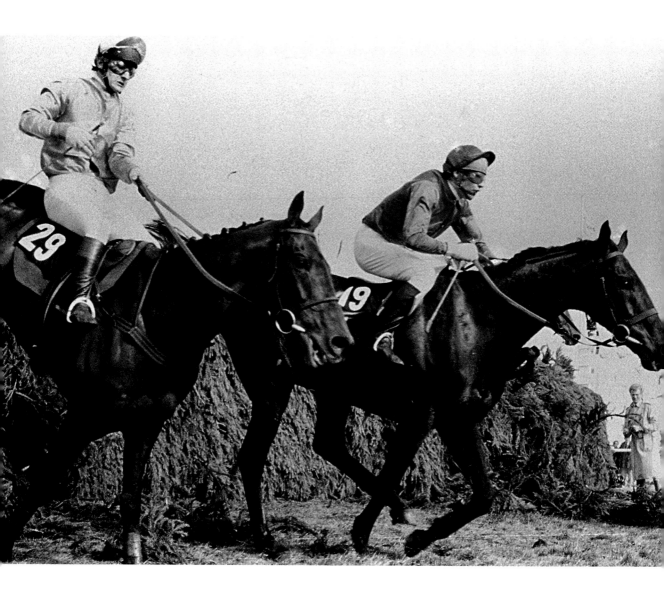

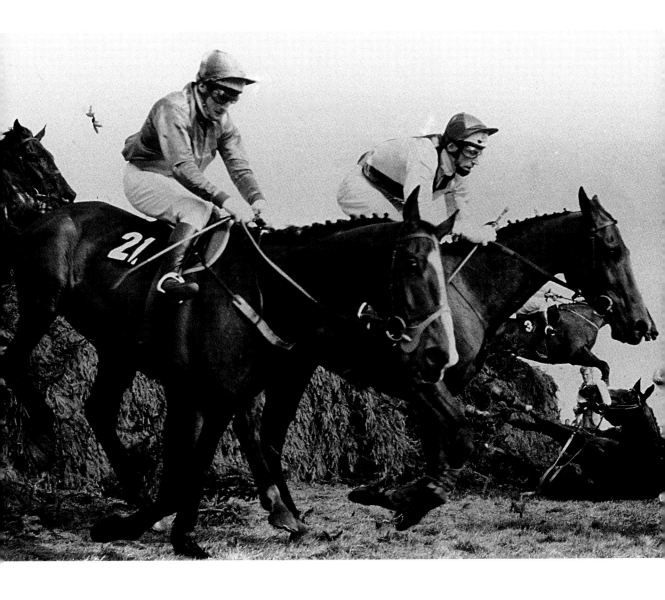

EYES DOWN

Intense concentration at a bingo hall
in Rawtenstall in Lancashire, 1980.

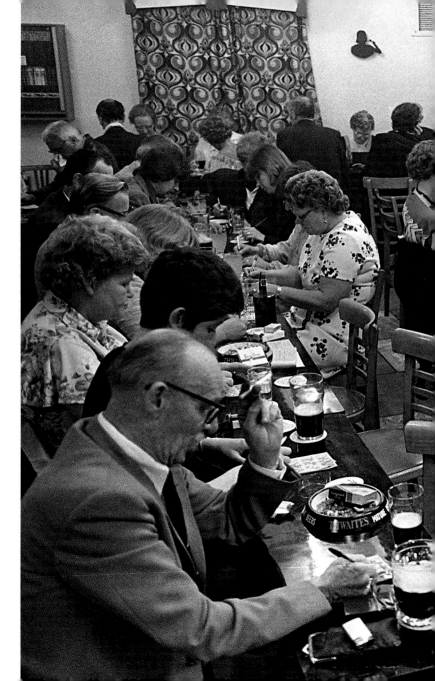

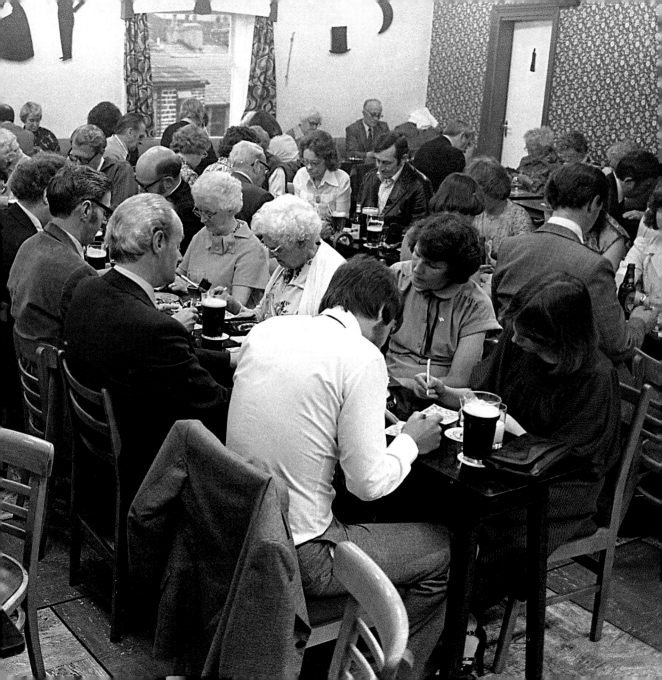

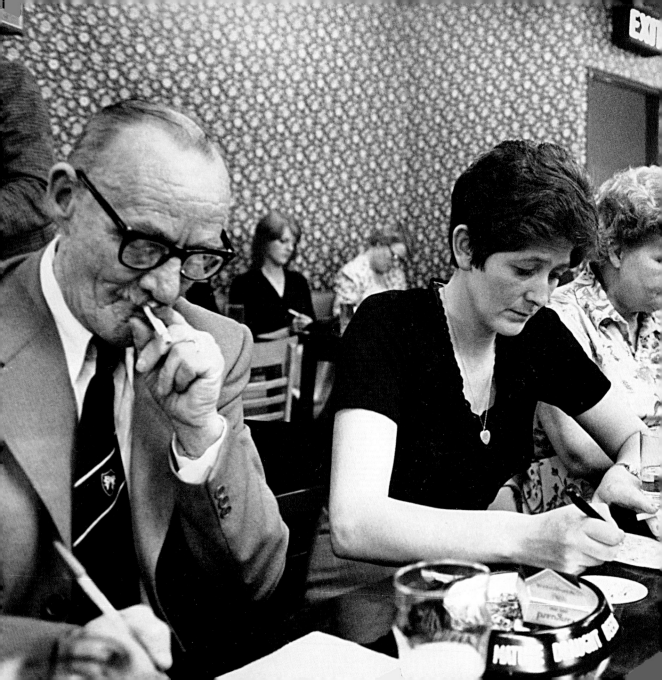

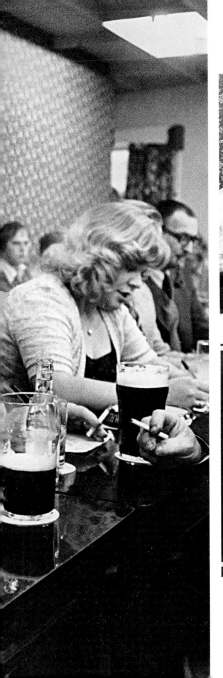

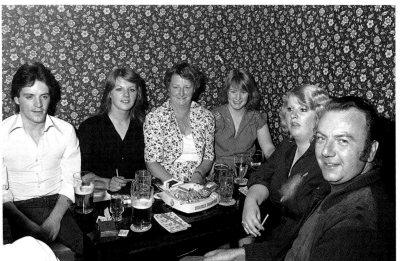

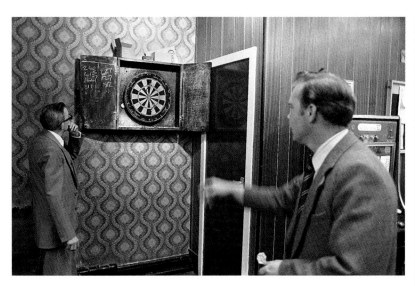

Such had been its popularity after the
regulated game was introduced in the 1960s
that newspaper headlines at the time included:
'Bingo's Hold on Womenfolk', 'Woman's
Bingo Bonanza' and 'Wife's Bingo Led to
Divorce'. Spot the women in the bar adjacent
to the bingo hall.

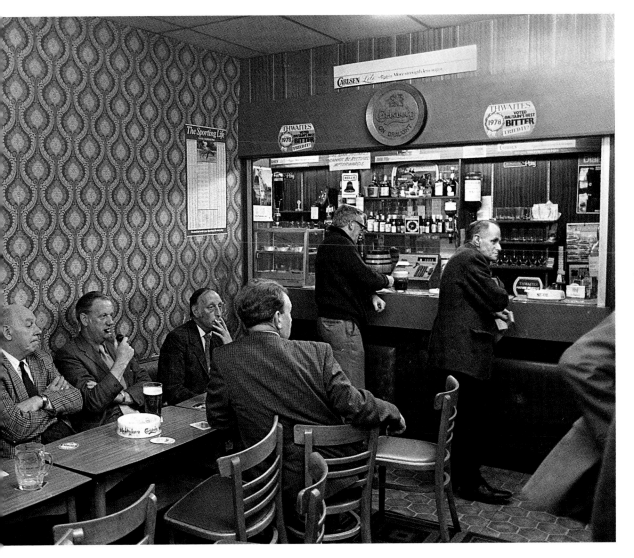

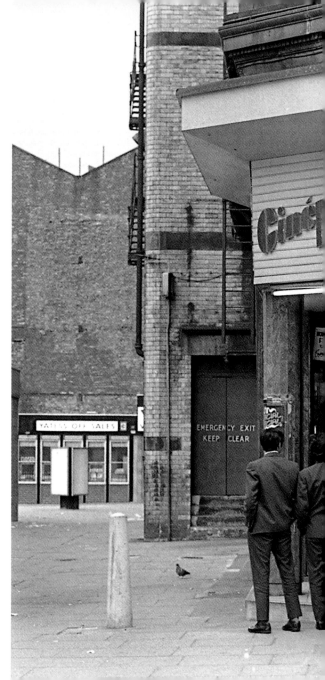

Smutty films at the Cinephone in Manchester,
1972, which was demolished to make way for
the less racy Arndale centre.

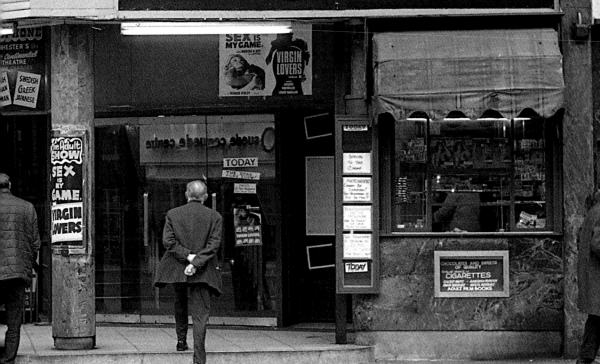

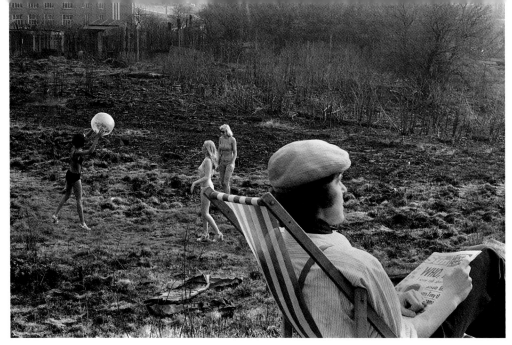

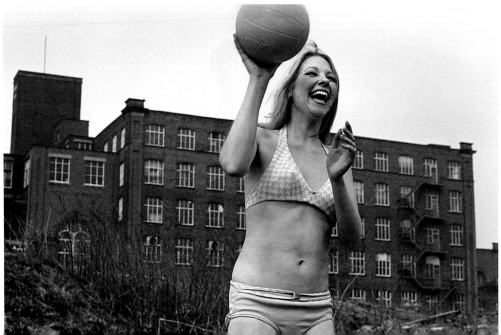

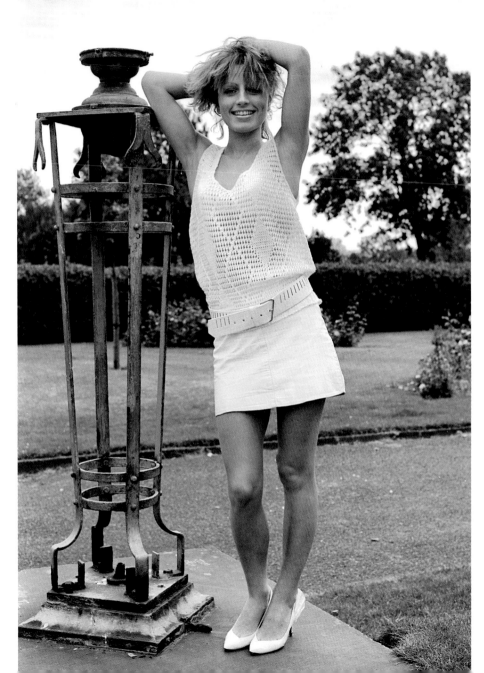

The decision to market Oldham as a tourist destination in 1976 prompts the BBC's *Nationwide* programme to dispatch John Stapleton and a clutch of bathing beauties to the former mill town.

RIGHT The illustrious winner of Miss Tarmac 1985.

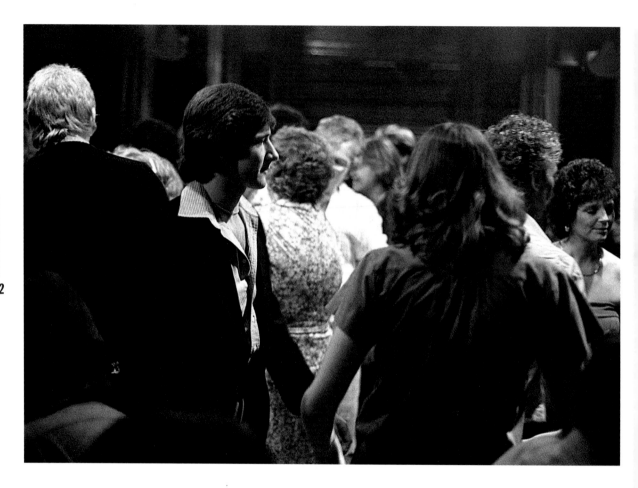

Saturday night at the Embassy Club
in Harpurhey, 1980.

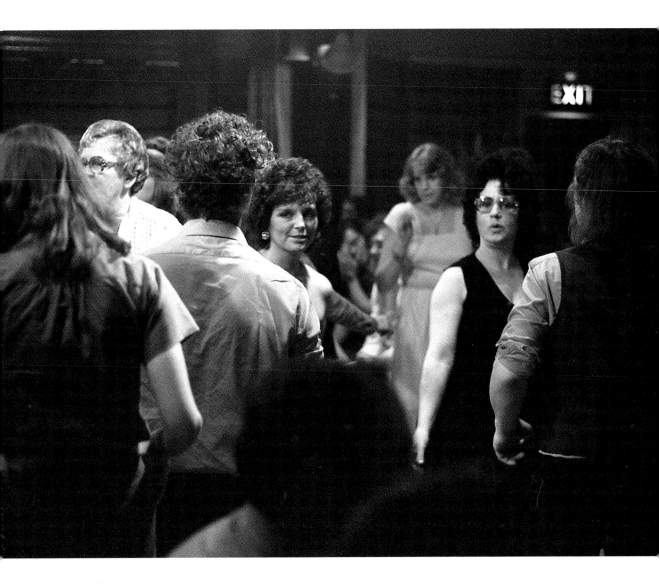

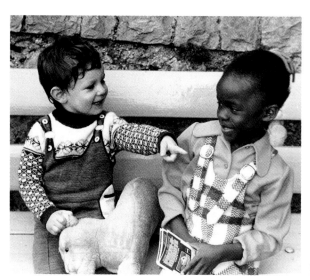

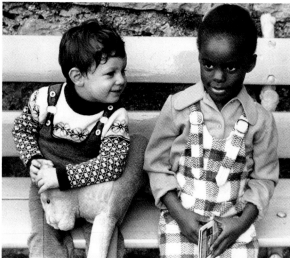

OUR KIDS

Mark was two when he met Lecky outside a cafe
near Manchester in 1973. It didn't take the toddlers
long to make a lunge for each other.

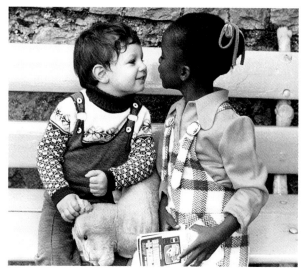

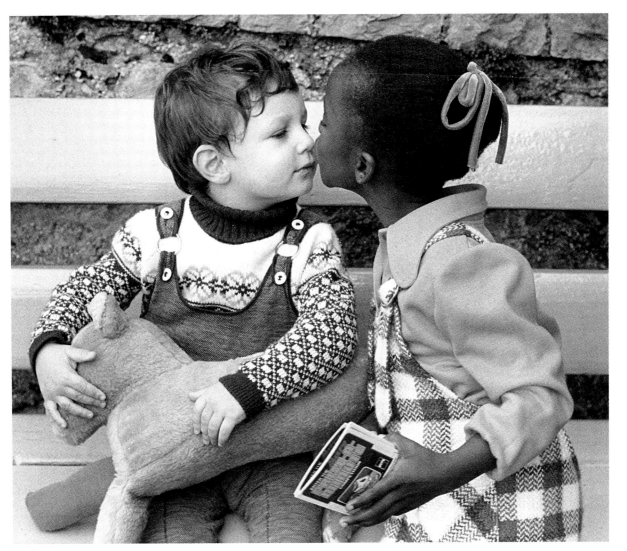

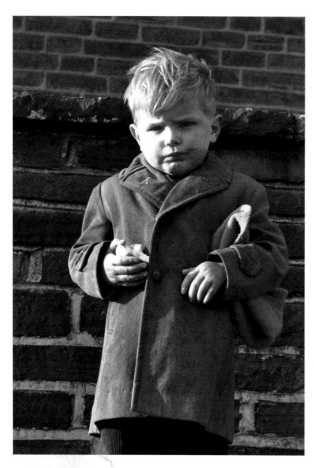

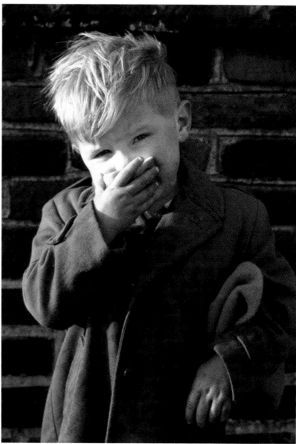

Bradford, 1958. I went past this little lad in a funny coat and hat on the street and dashed off to get my camera. He was still there when I came back – so was the snot. (OVERLEAF) With hat on.

OVERLEAF, RIGHT One-year-old Philip is somewhat unimpressed by his sister Alice. But the image won a major prize in M.I.L.K. – the world's biggest photographic competition in 1999.

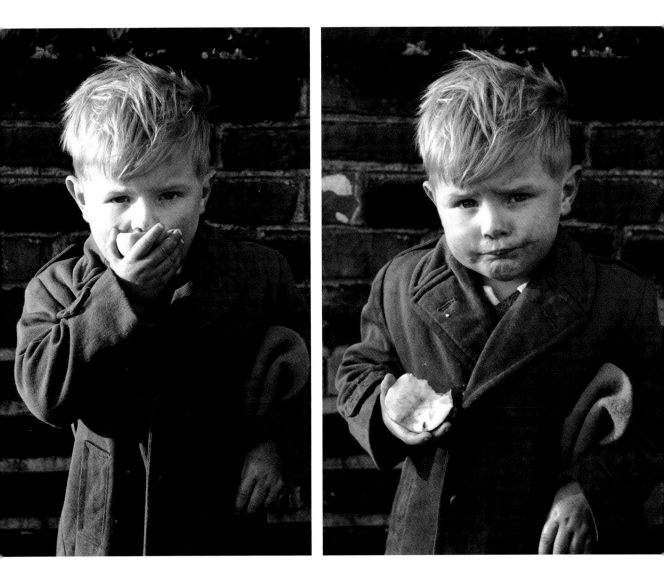

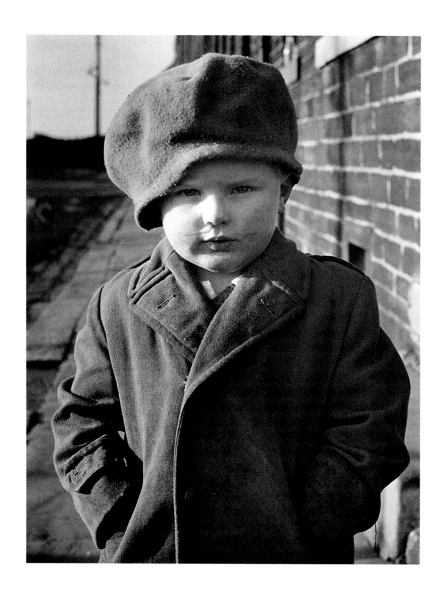

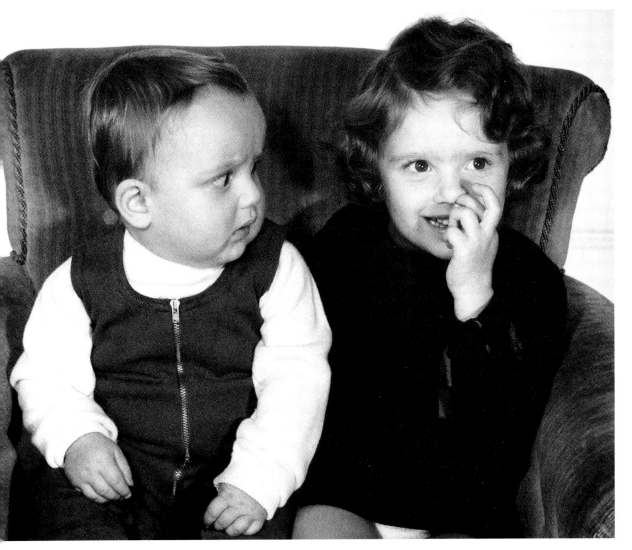

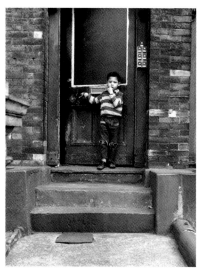

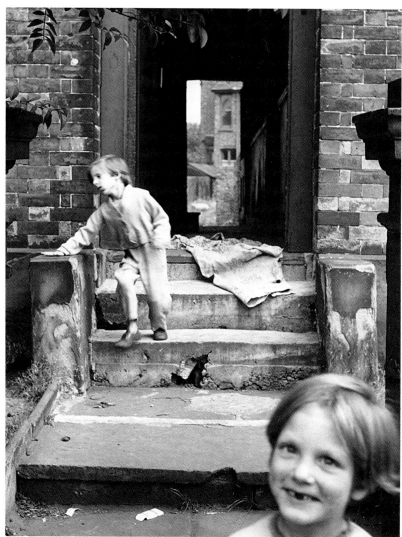

The year England won the World Cup – but parts of Cheetham Hill in north Manchester are looking decidedly Dickensian. The 1966 photos of these two boys (RIGHT) looking urchin-like in a doorway appeared in the *Manchester Evening News*: their shamed father then went out and got a job to look after his sons.

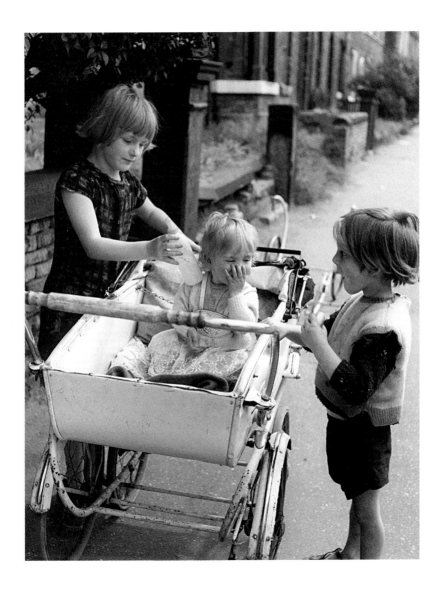

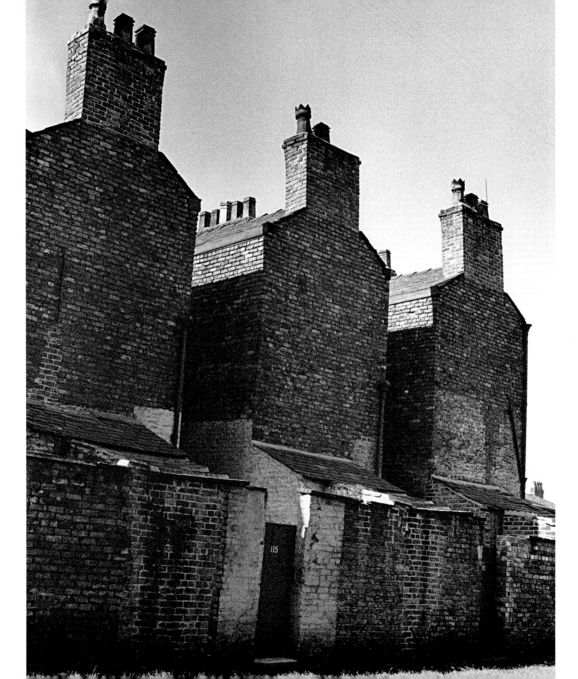

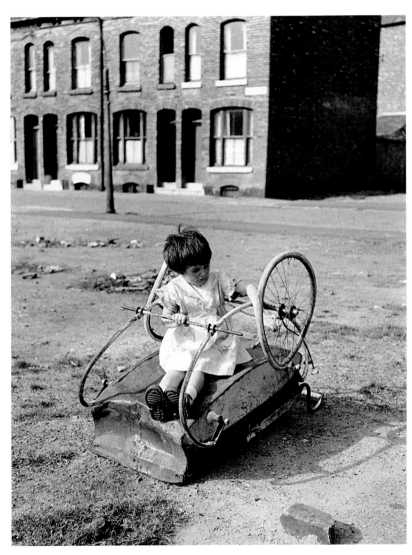

Moss Side in 1964, before the terraces had given way to the tower blocks. The 1960s were an era when, up North at least, real poverty – and character – persisted. Moss Side was still a pretty rough place in parts, but there wasn't the menace that would come later. The kids would always come up to you and cheekily demand you took their photo.

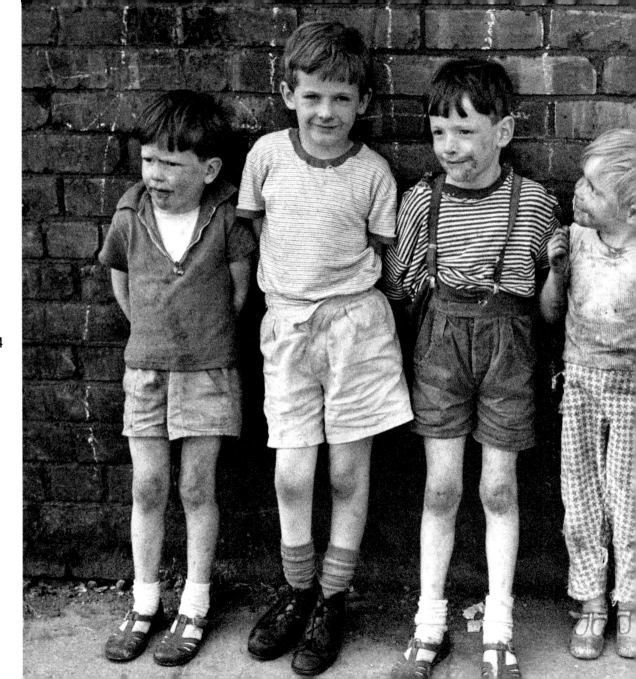

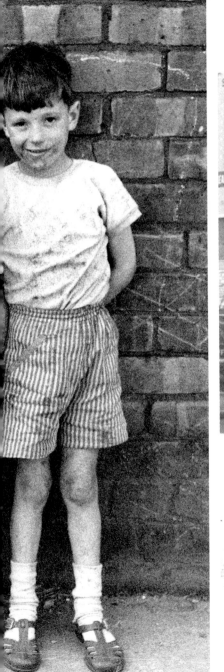
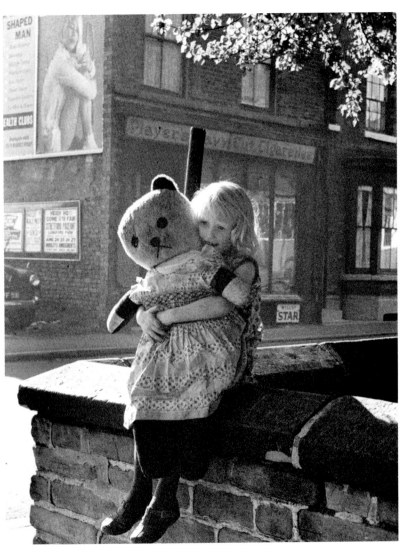

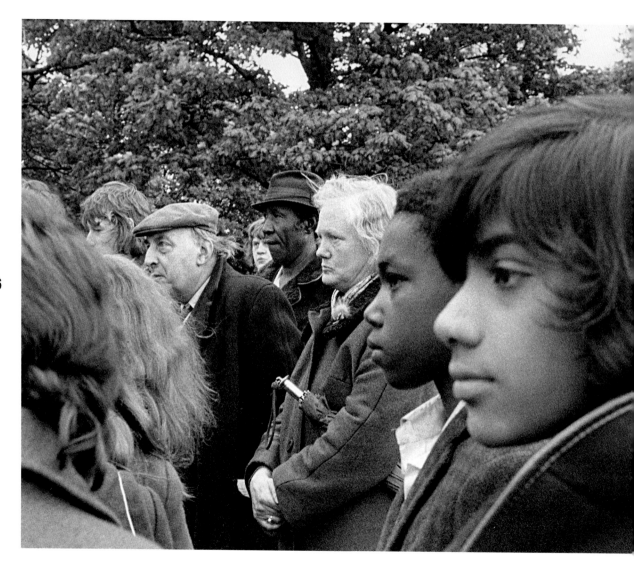

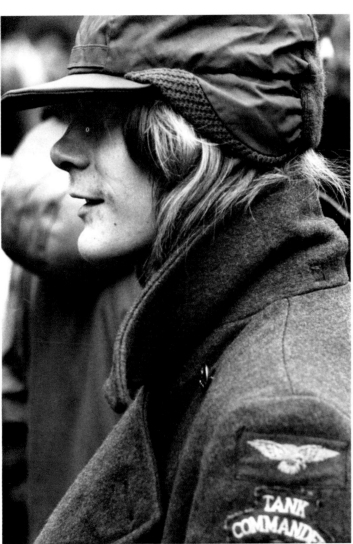

MOSS SIDE STORY

The story continues. A later
multicultural slice showing
how Moss Side had changed
during the 1960s – with an
Afro-Caribbean festival in
Alexandra Park in 1972.
But tensions erupt in
rioting in 1981.

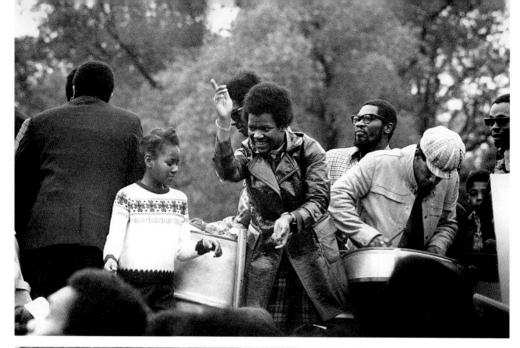

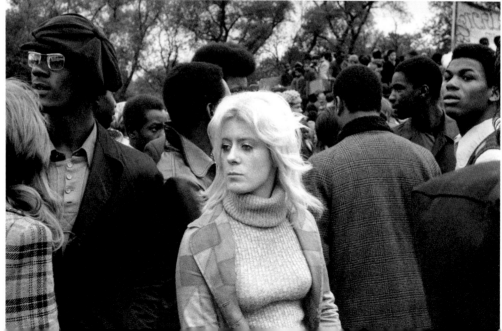

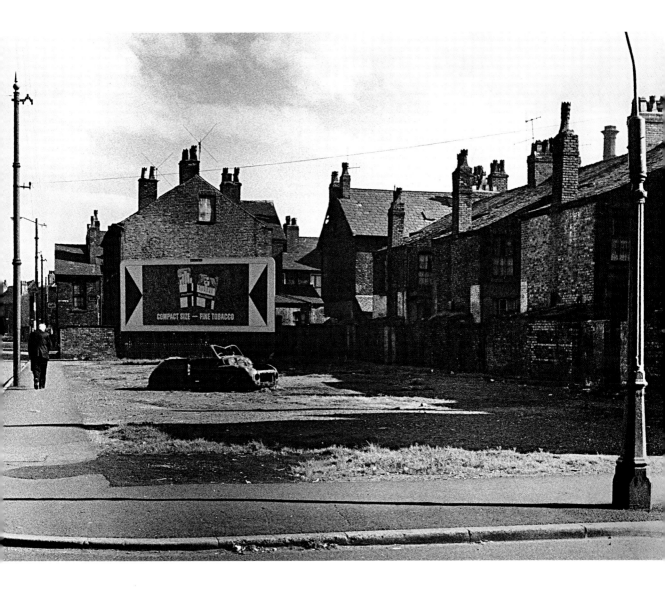

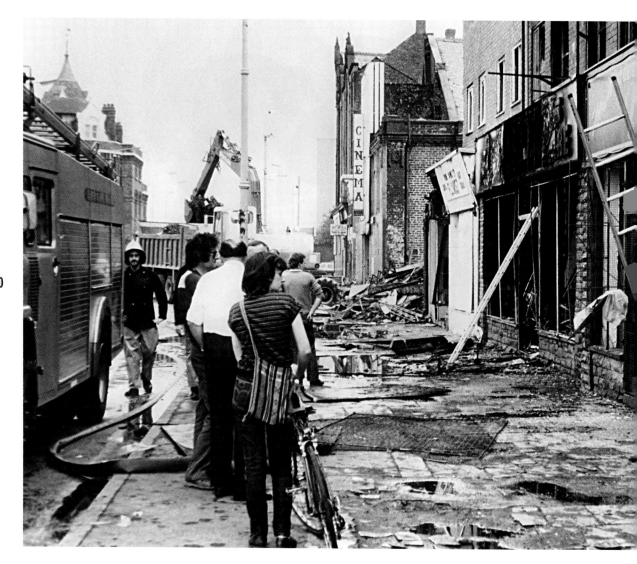

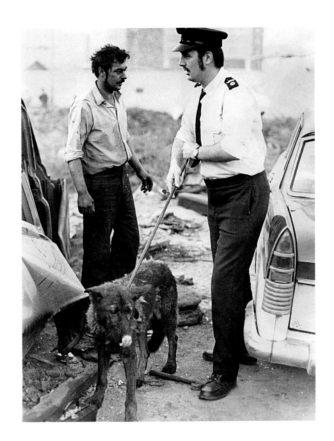

Cleaning up after the 1981 Moss Side riots. Inner-city disturbances also flared in Liverpool, Leeds, London and Birmingham – set against an early 1980s backdrop of unemployment, racial tensions and strained police relations.

RIGHT An RSPCA inspector leads Prince away after a house fire, 1981.

BIG DAY OUT

It all used to happen at Belle Vue. Once the entertainment centre of the North West, it pulled in two million people a year before its demise in the 1980s. These photos are from a Variety Club day out in 1969, when kids were happy just to watch a Great Manchester Police Alsatian chase a constable (OVERLEAF).

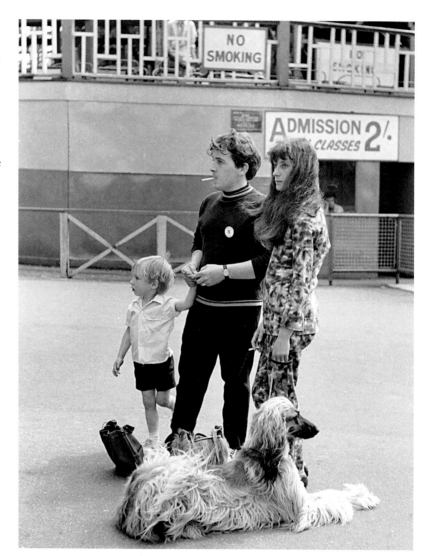

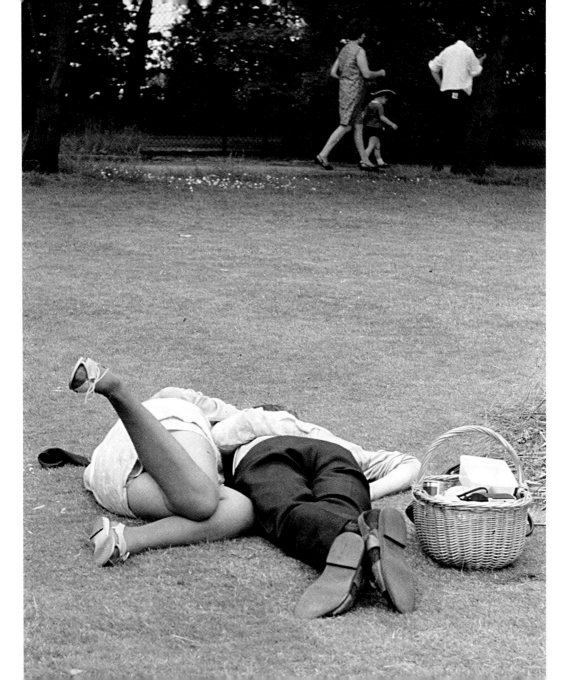

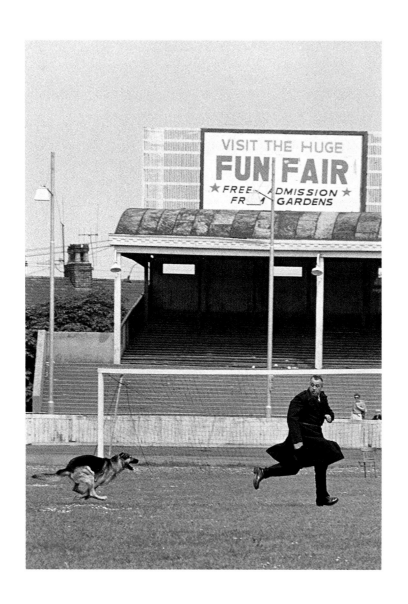

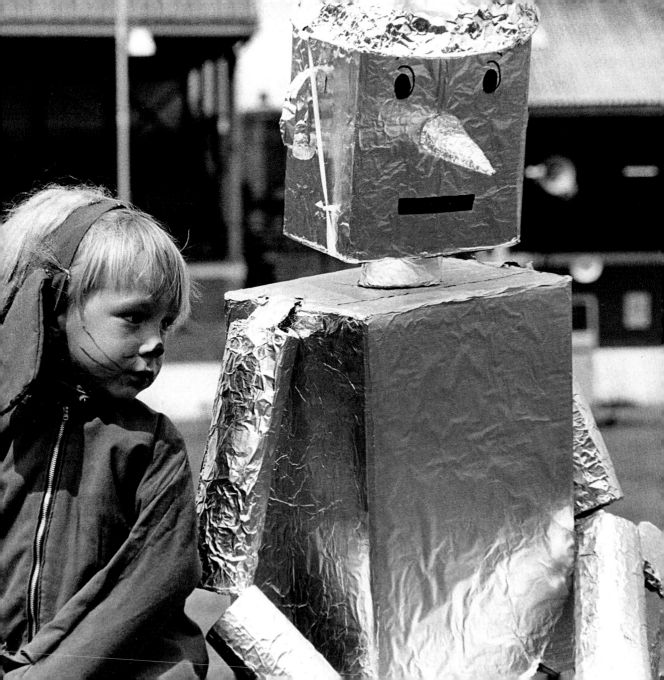

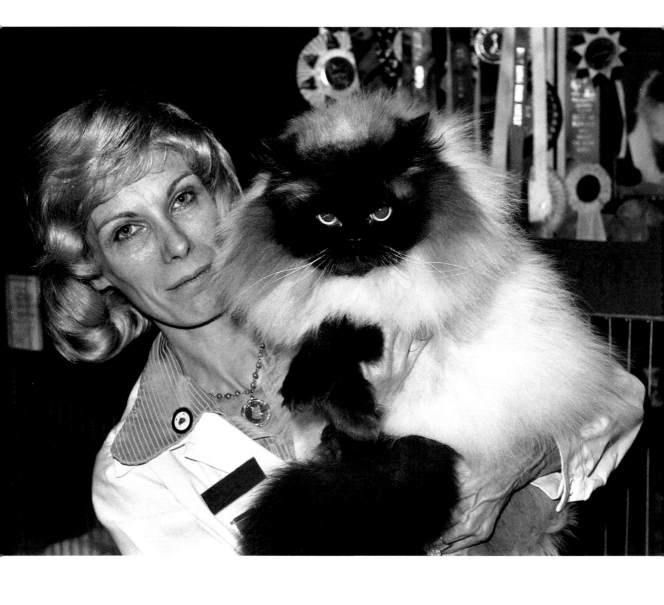

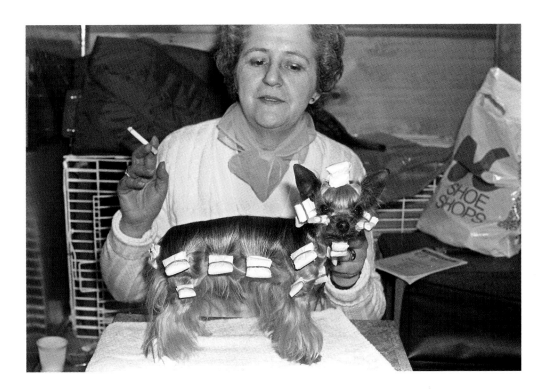

THE TRUTH ABOUT
CATS AND DOGS

The pampered pooches and coiffured cats on show
at Belle Vue, 1980. No-nonsense Crufts (OVERLEAF).

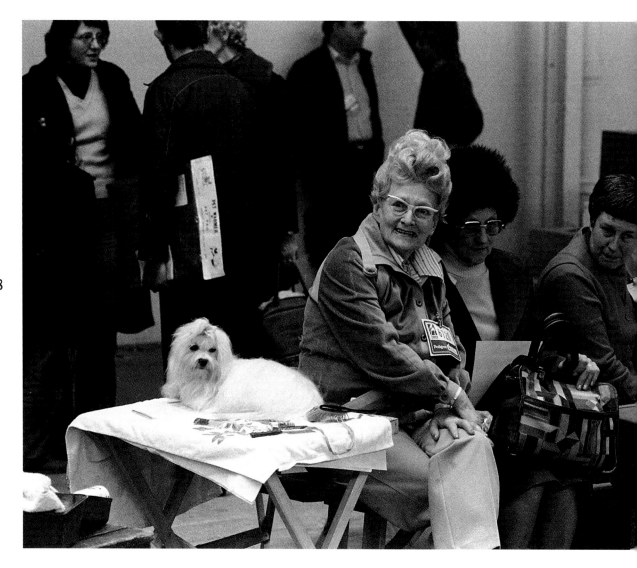

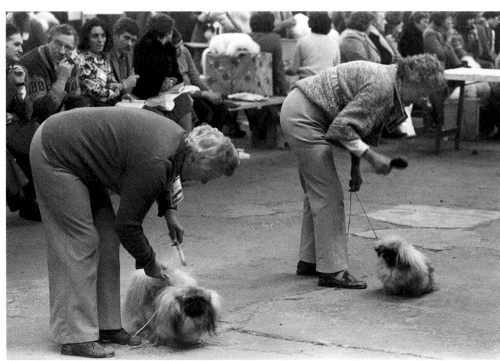

FAMOUS FACES

British fascist leader Oswald Mosley came to Manchester in 1956 to campaign for his post-war Union Movement. But the 'heavies' (FAR RIGHT) weren't happy with me taking a photo of them and tried to bundle me out. The fracas was cue for the police to come in and shut down the rally.

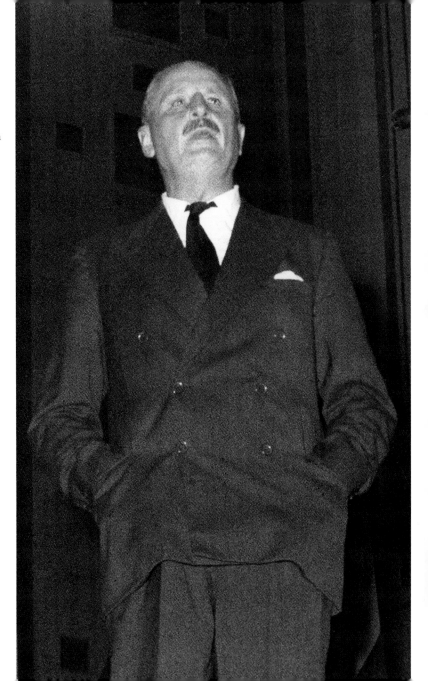

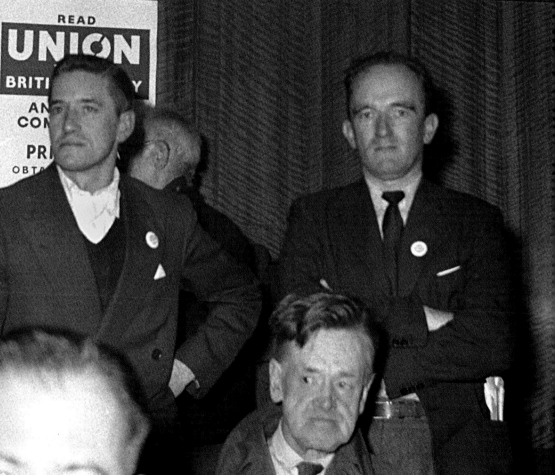

Huddersfield-born former Labour Prime Minister, Harold Wilson, in contemplative pipe-smoking mood in his Huyton constituency, 1980.

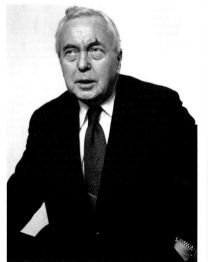

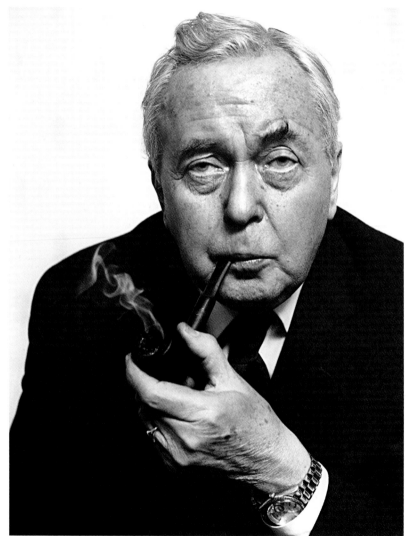

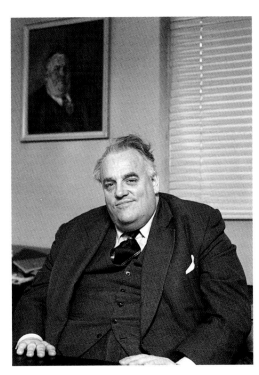

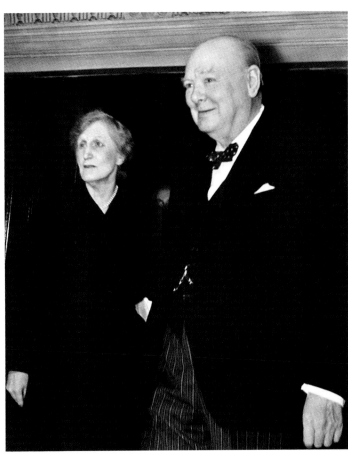

LEFT Larger-than-life Rochdale politician Cyril Smith, 1980. And, in 1951 (RIGHT), Winston Churchill, then Conservative leader, came to Colne Valley to campaign for his dear friend Lady Violet Bonham Carter who was standing for the Liberals.

HOW THE OTHER HALF LIVE

There can't have been too many cigarette holders in
Manchester in 1964 – an elegant slice of Didsbury life
for Nat, Maisie and the self-styled 'Prince'.

RIGHT Race-goers at Chester, 1981.

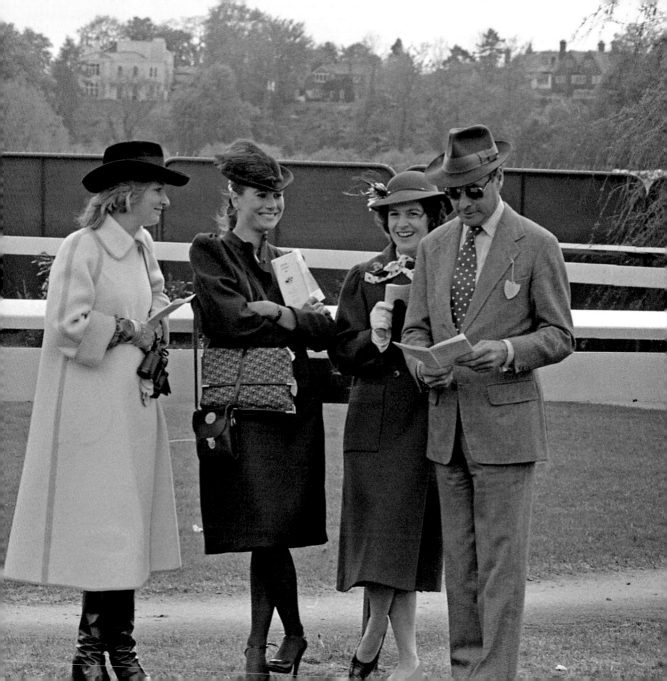

The New Year's
Day hunt at
Holcombe, 1980.
One of the oldest
hunts in the
country, Holcombe
traces its roots back
to Norman times.

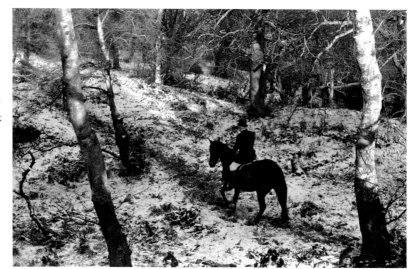

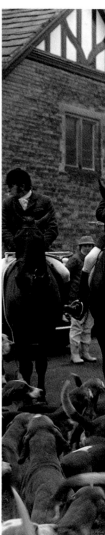

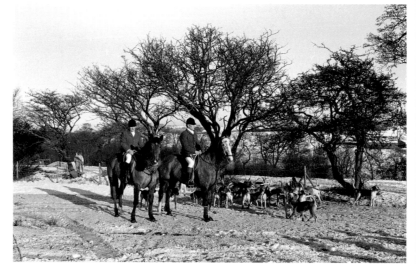

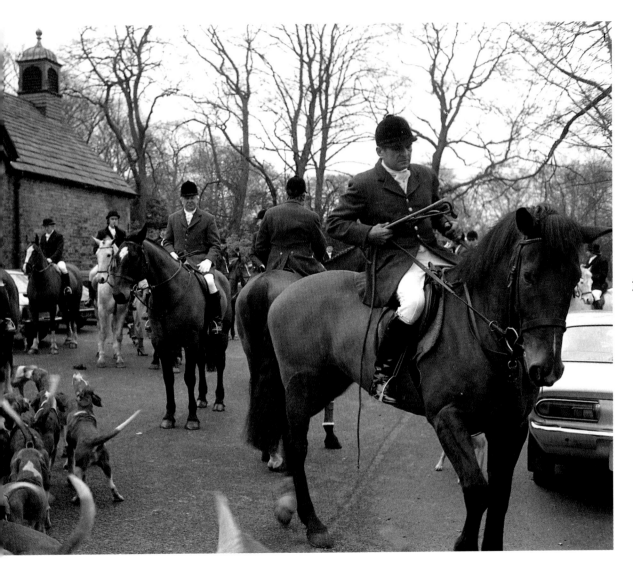

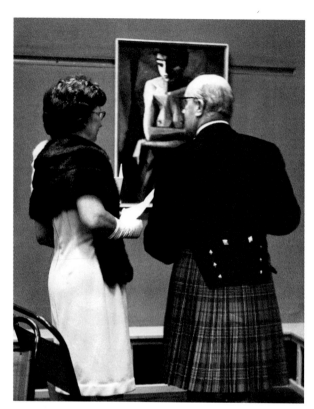

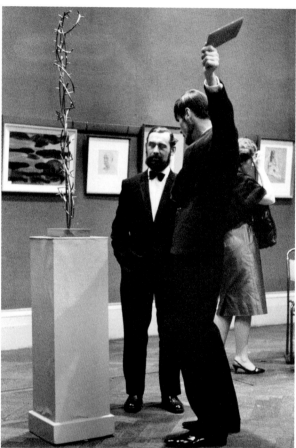

Fancy-pants Manchester. An evening called *Sympatico*
at the Manchester Academy of Fine Arts – for *them that
were cultural*, 1967.

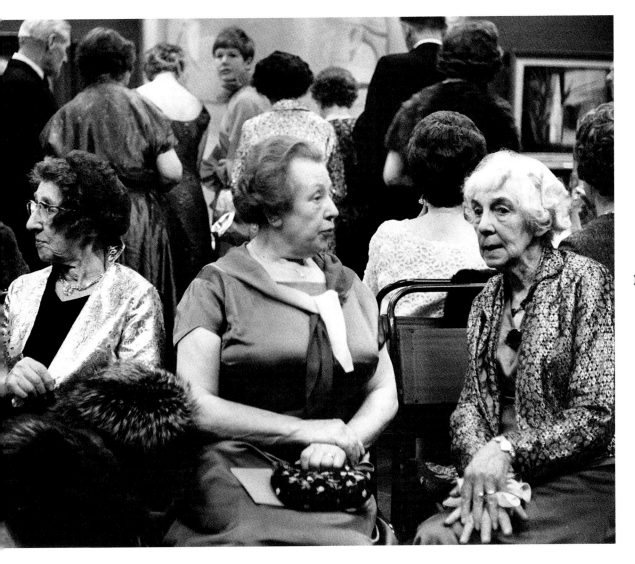

The fresh air of the Delamere Forest in Cheshire was the destination for some Jewish children from the city with special needs, who were sent to a small but inspirational school, 1961.

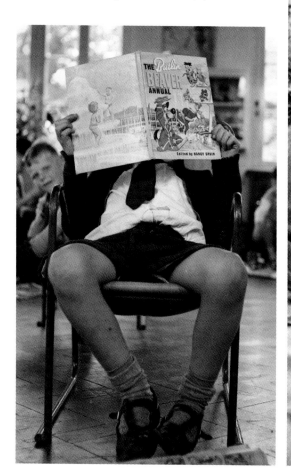

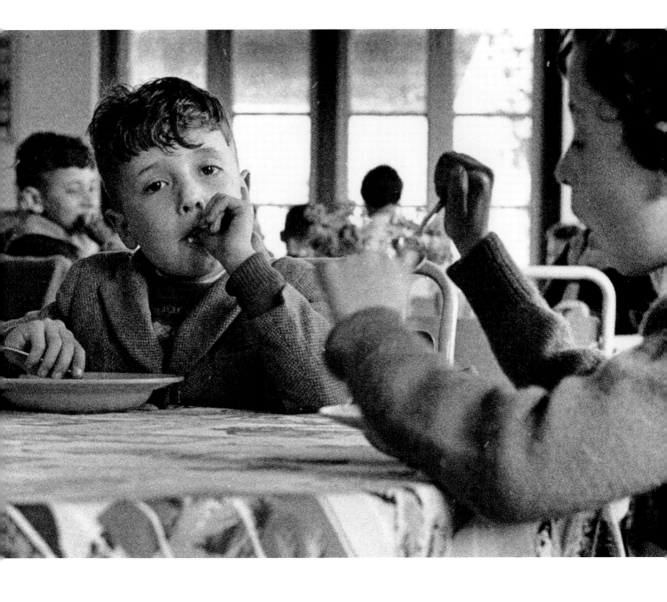

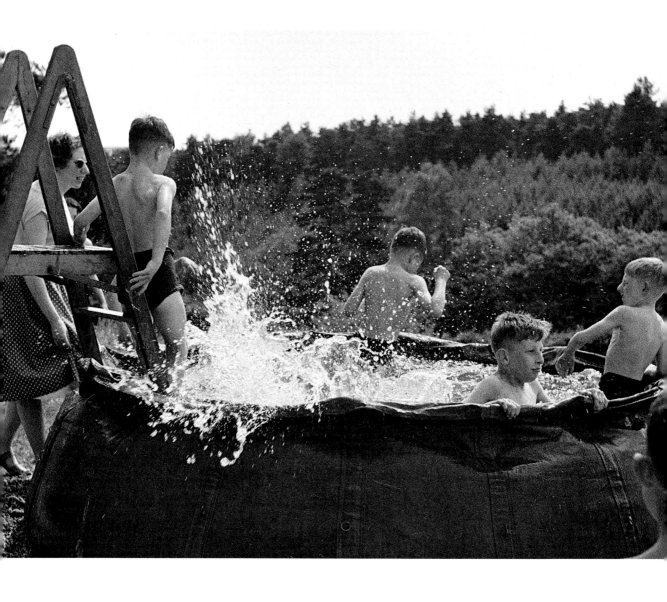

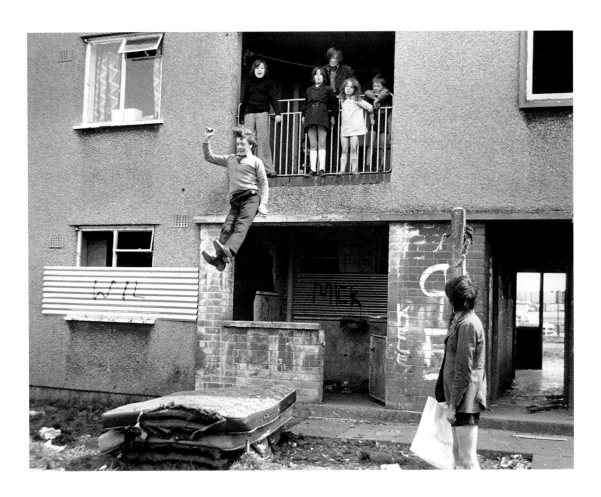

Afternoon entertainment on a Kirkby estate, 1973. I was
walking through the estate taking photos of the area when
I came across some kids who'd piled up some mattresses
for a spot of pre-Playstation improvised amusement.

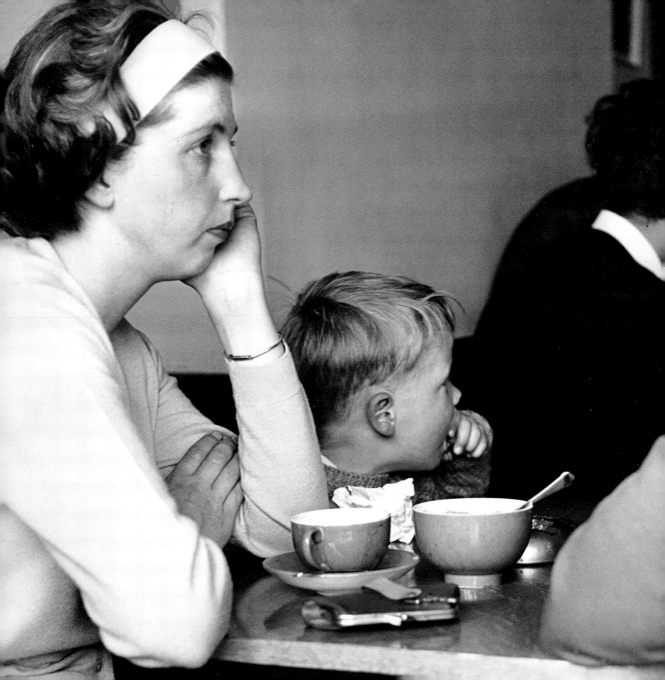

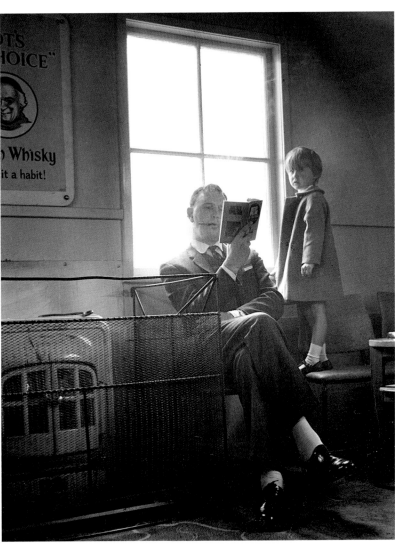

Supposedly on
holiday, passing
the afternoon in
an Abersoch cafe
in 1964 – and father
and daughter in
the waiting room at
Orkney Airport, 1967.

BEFORE STARBUCKS

The pre-high street chain days when Sue Lawley's
fun side was front-page news, 1972 and 1984.

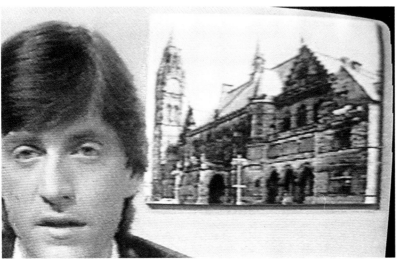

NORTHERN TELEVISION

Moving to Salford, the BBC returns to a tradition of pedigree
North West broadcasting. Granada launched many a show
and face. Richard Madeley reads the regional news in 1986 –
and *Look Northwest* broadcasts in 1981.

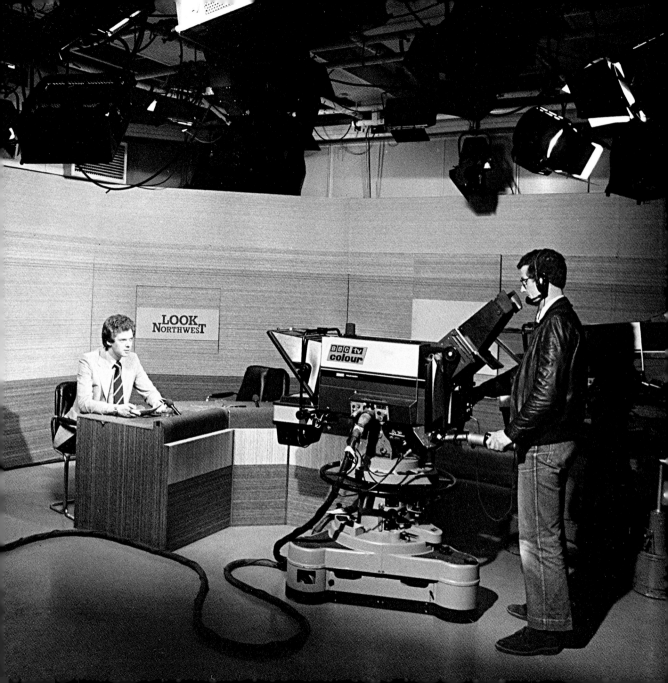

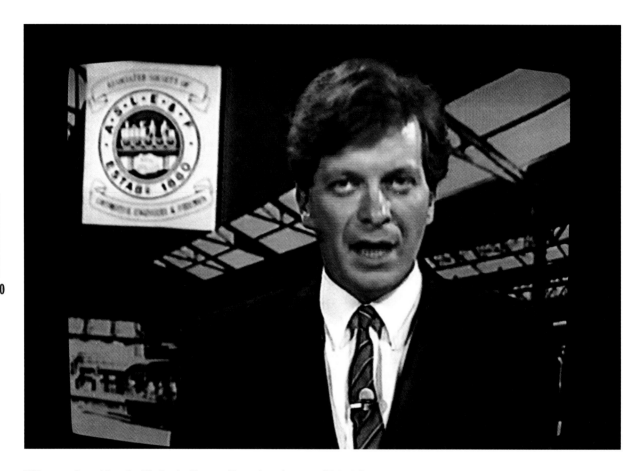

When not launching the Hacienda, Factory Records and some of Britain's greatest ever musical acts, Tony Wilson carried on with the newsreading day job – delivering what looks like news of industrial action, 1986.

RIGHT Stuart Hall is sent by the *Nationwide* TV show to cover a skateboard championship, 1978.

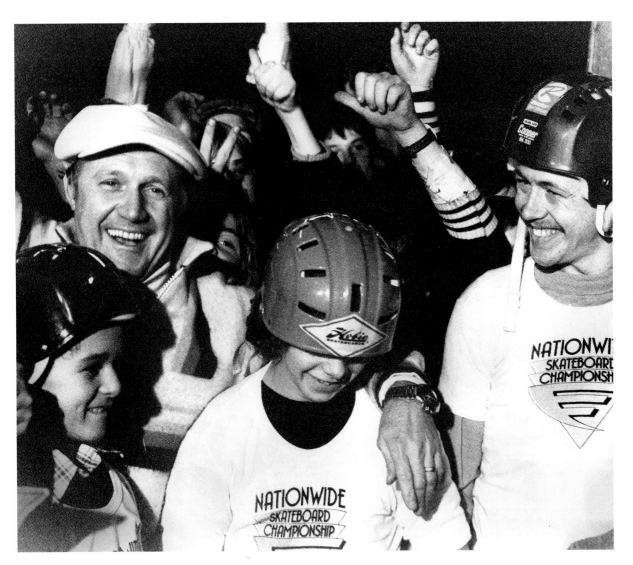

NORTHERN SOUL

The Hallé orchestra's legendary
conductor, Sir John Barbirolli,
photographed in 1968 when he was
appointed Conductor Laureate.
He is credited with having saved
the war-ravaged orchestra, which
he took over in 1943, and turning
it into a world force.

RIGHT The Hallé choir, 1968.

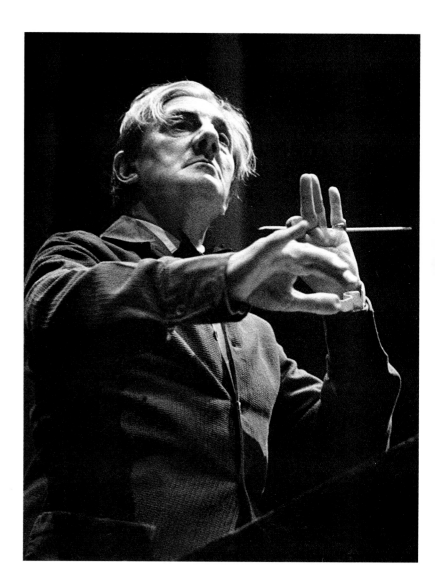

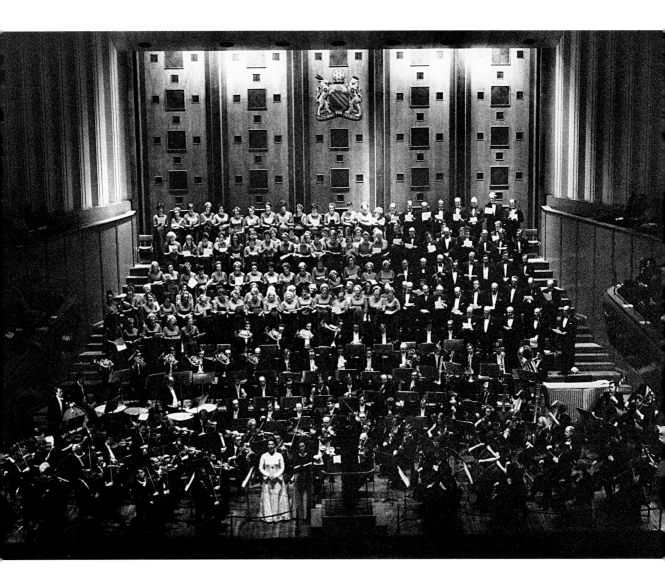

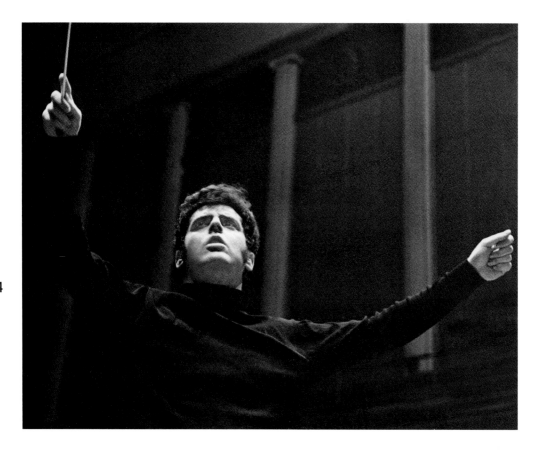

Israeli conductor Daniel Barenboim leads the Hallé choir in 1969. He remarked:
'As as orchestral playing is concerned, I learned most of what I know from Barbirolli.'

RIGHT One of Britain's best jazz drummers of the 1960s – Phil Seaman playing
at Club 43 in Manchester. A dishevelled figure who ambled onto the stage, fag in
mouth, he let rip on the drums and no one could touch him. Seaman battled drug
and alcohol addiction and died in his mid-forties, six years after this 1966 photo.

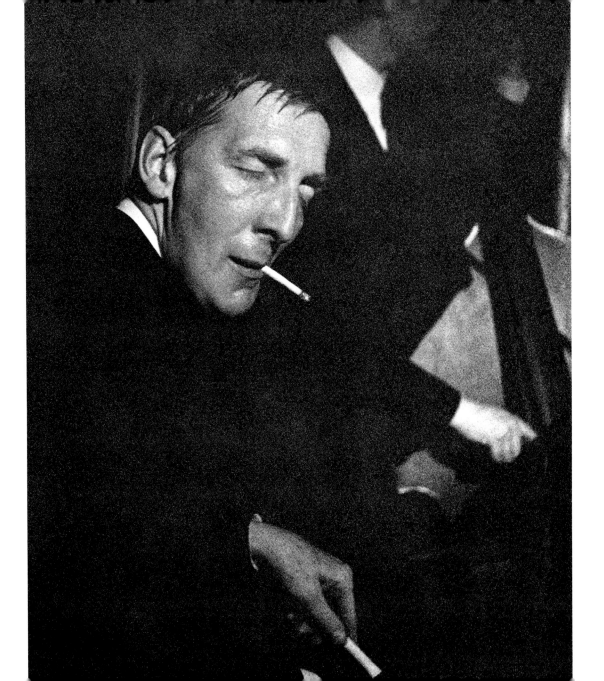

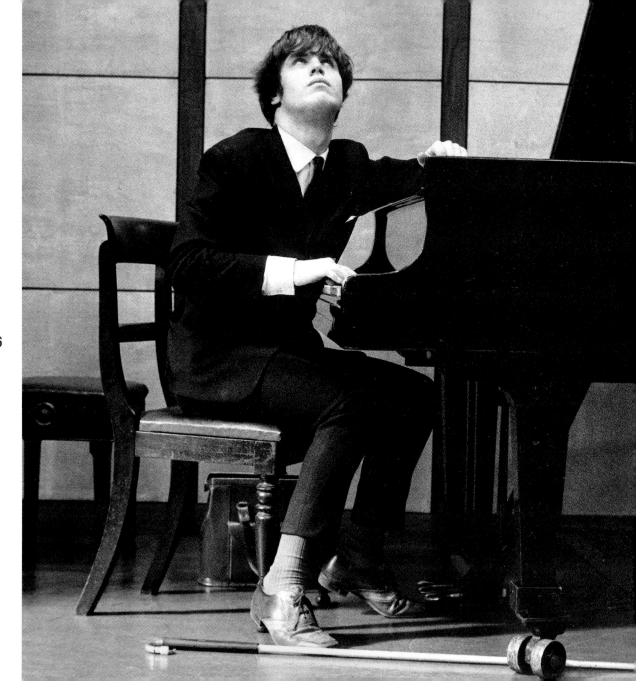

A blind piano tuner before a recital at the Friends Meeting
House in Manchester, 1969 – and the extraordinary pianist
John Ogdon performing in 1969 and pictured overleaf. Raised
in Manchester, Ogdon was able to play pieces at sight and
composed more than 200 pieces – while battling ill health,
both physical and mental.

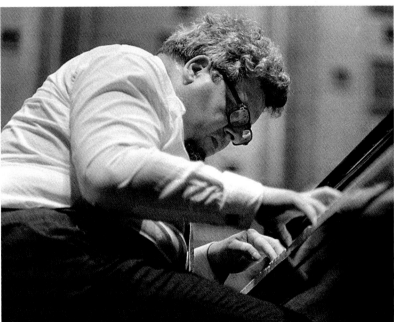

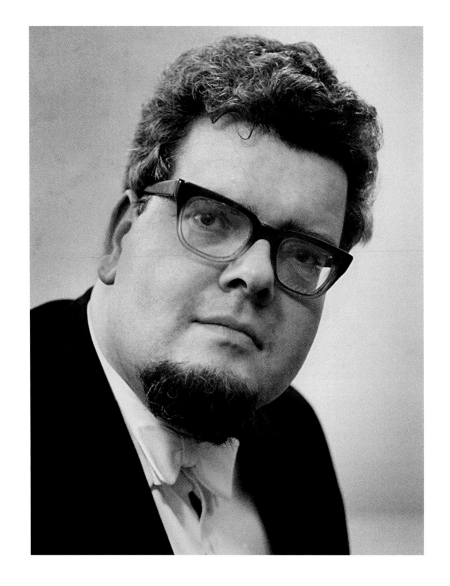

Salford-born composer Sir Peter Maxwell Davies, who was appointed Master of the Queen's Music in 2004 (2000).

THIS CHARMING MANC

Morrissey during his most unusual interview – at the home of 13-year-old fan Tim Samuels (my son and now a TV journalist), who was interviewing The Smiths frontman for his school newspaper. Taken in 1989 at the height of his solo success. Morrissey stayed all evening, chatted for hours, signed Tim's posters – but drew the line at stopping for my dinner.

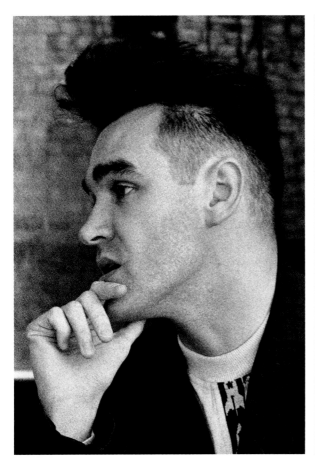

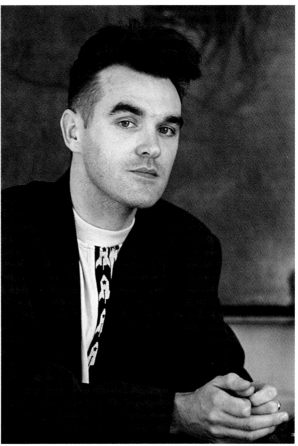

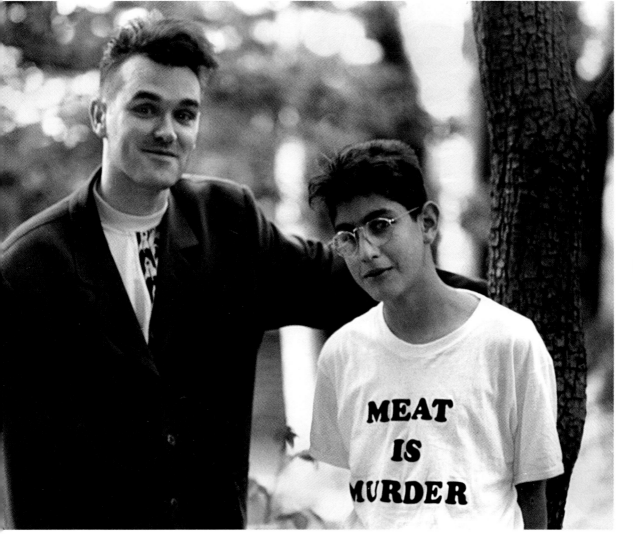

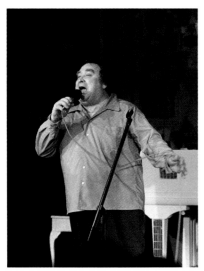

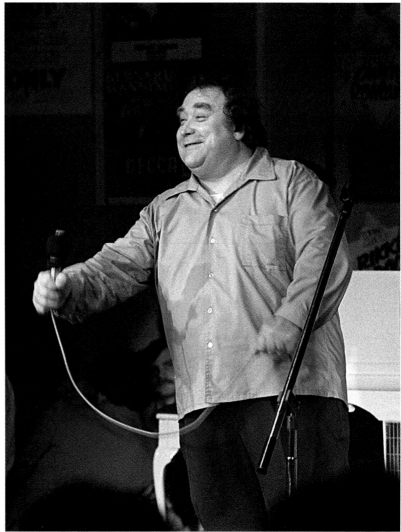

LESS CHARMING MANC

The controversial but utterly Northern comedian Bernard Manning performing at his Embassy Club in 1980 – with his Cadillac on display outside. As a Mancunian, he couldn't resist a dig at his Merseyside neighbours: 'I love to visit Liverpool … to see my hubcaps.'

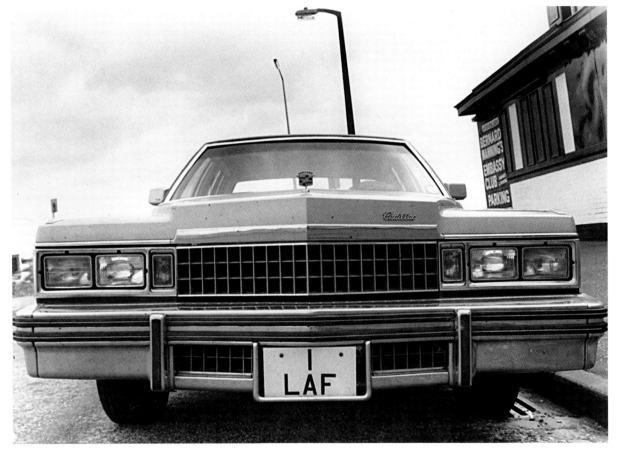

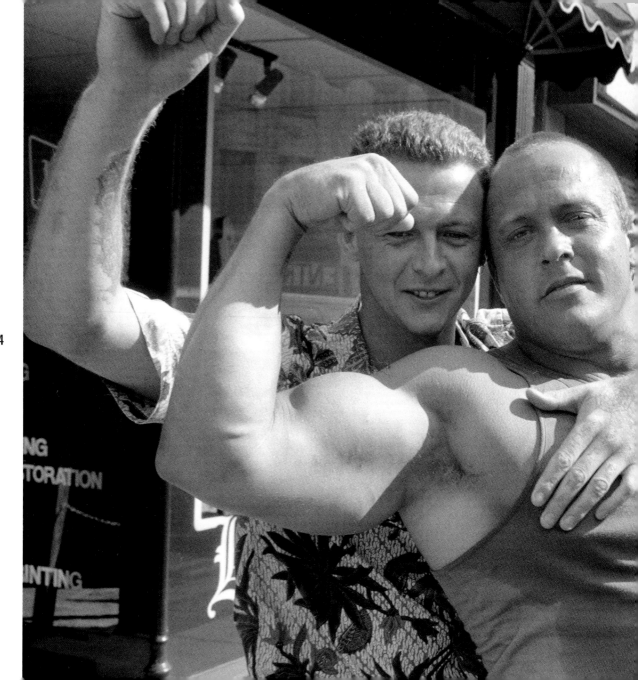

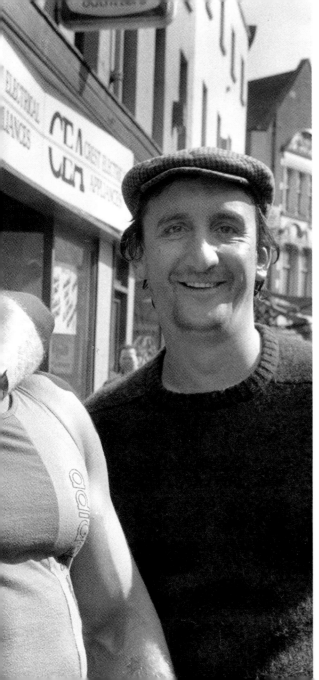

THE OTHER BODIES

Three guys saw me with my camera on the street in Stoke in 1987, came over to pose and then walked away with not a word being uttered between us.

BELOW Derek Ibbotson running for England against the Soviet Union in 1954 at the old White City track – where he was to run the first ever four-minute mile four years later.

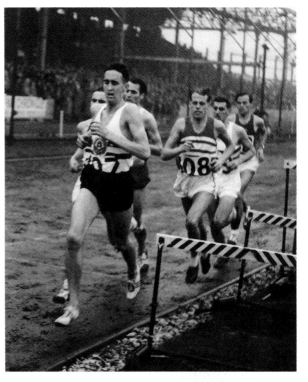

A yoga demonstration in
Deansgate by Ramon Bey
– also known as Albert E.
Buxton from Middleton
Junction. In 1955 I was an
early practitioner of yoga
but had to keep it quiet in
the pre-Beatles days. People
thought you were a bit of a
nutter if you did yoga back
then. Apart from Albert,
that is.

OVERLEAF A tug of
war at a Penrith rugby
club gala, 1983.

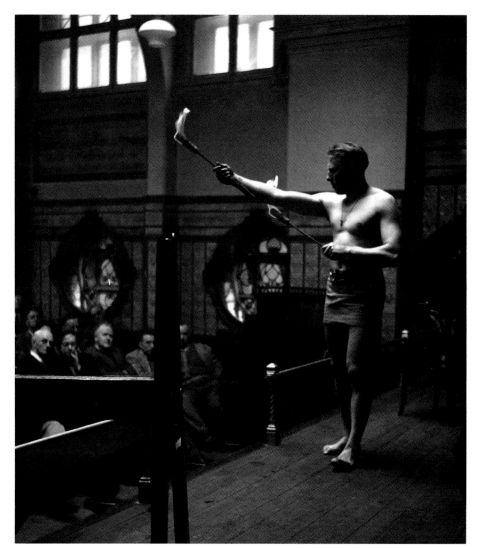

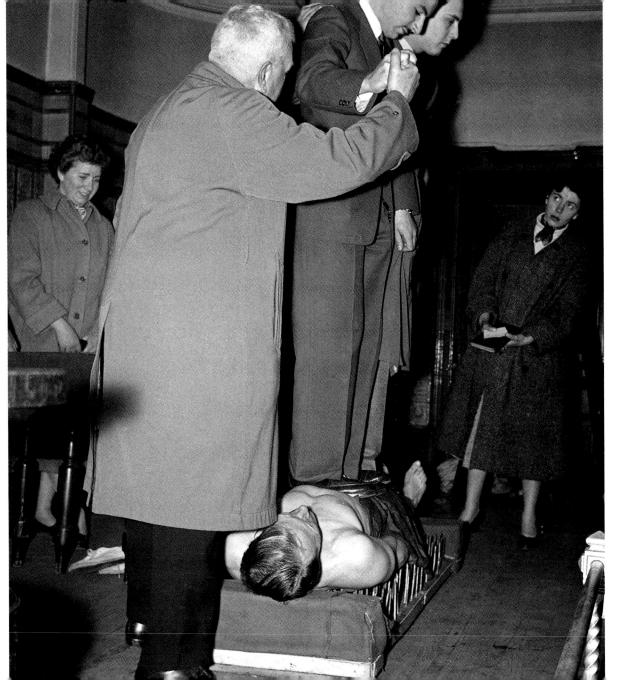

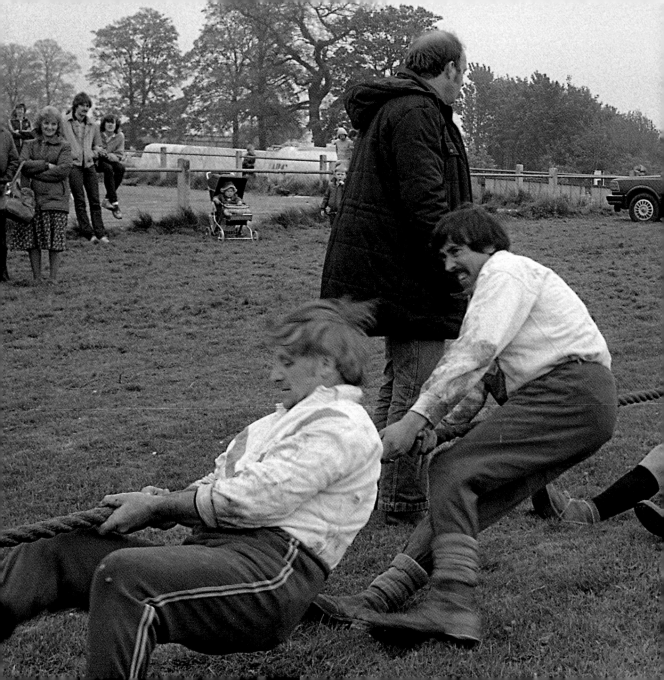

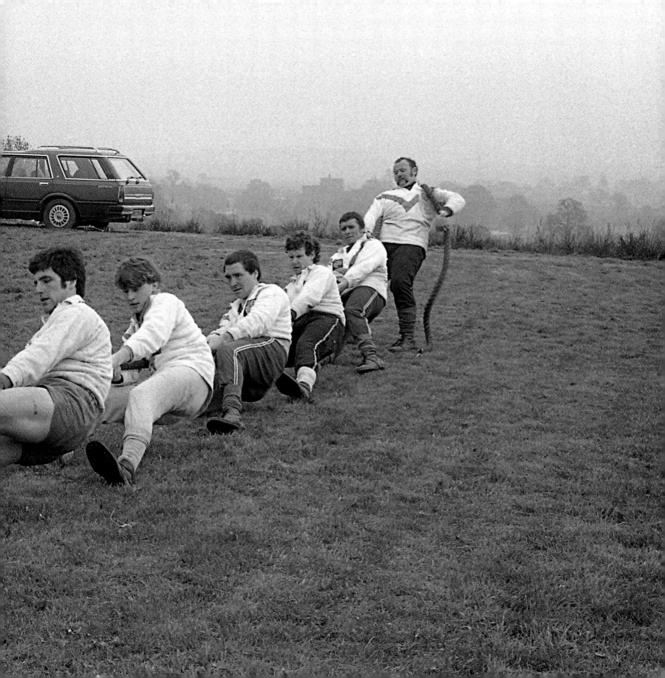

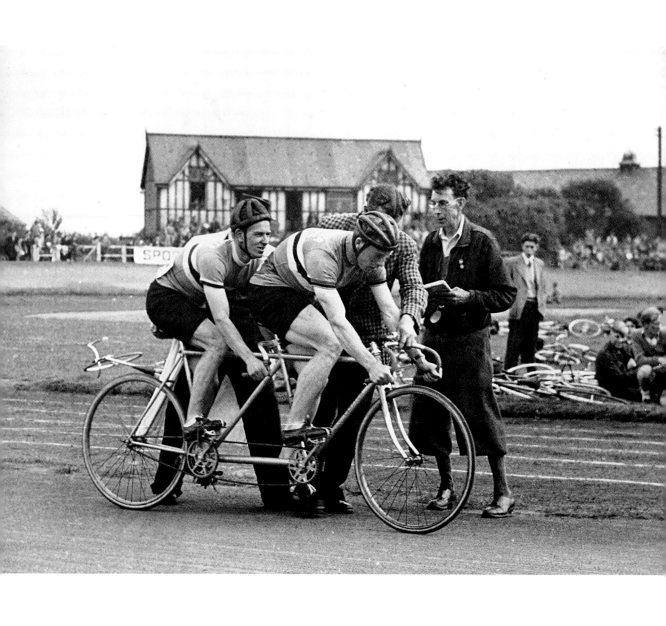

Leading English cyclist Reg Harris at the Fallowfield track –
which was later named after him in 1947. That year he won the
amateur sprint title and the following year two silver medals
at the Olympics.

RIGHT Sid the cycle mechanic, a familiar face around
Withington, pictured in 1983.

OVERLEAF A gruelling cross-country in Winton, 1954.

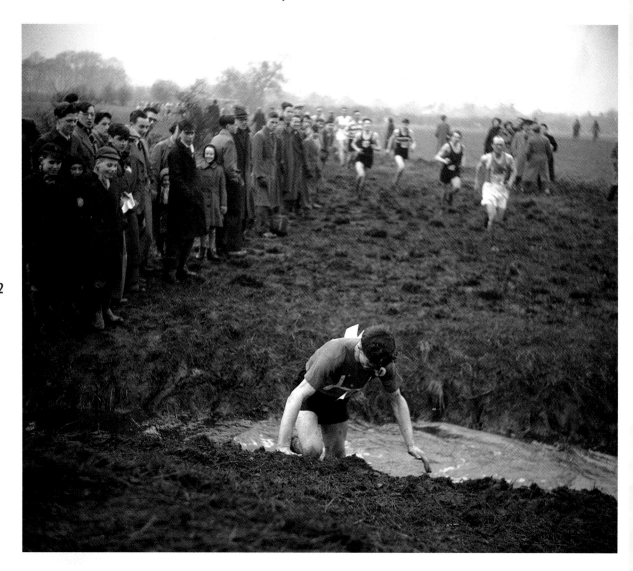

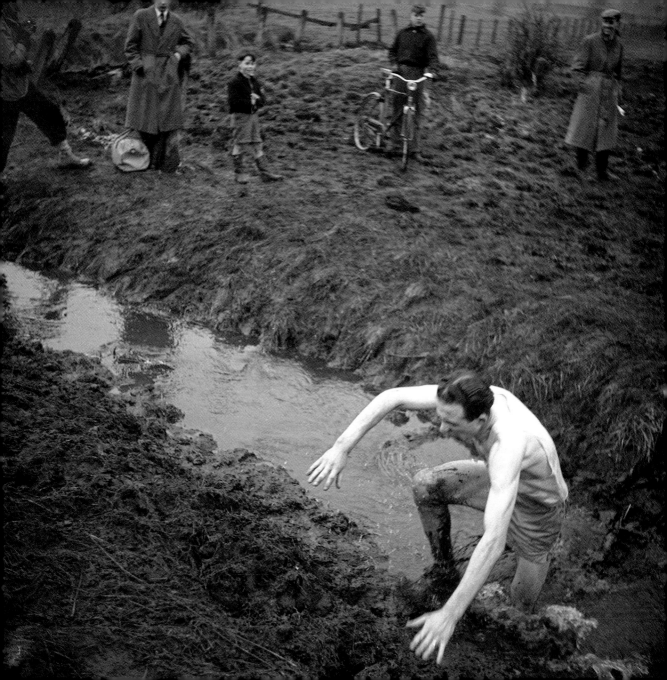

THE PUBLICITY OFFICE IS IN THE TOWN HALL EXTENSION

MANCHESTER ROAD SAFETY COMMITTEE
HALF OF ALL WINTER CAR ACCIDENTS INVOLVE
SKIDDING
LEARN TO CONTROL SKIDS ON
MANCHESTER CORPORATION SKID PAN
APPLY ROAD SAFETY OFFICER, 159, DEANSGATE, MANCHESTER 2. TELE

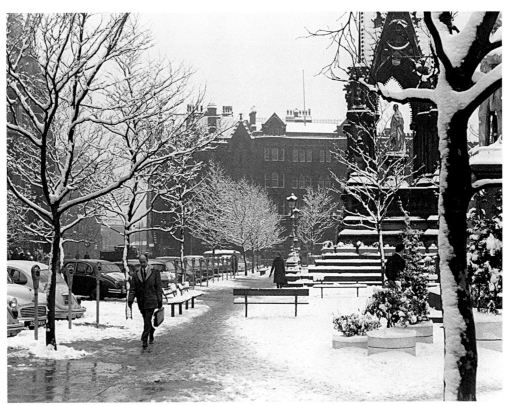

SLIP AWAY

Motorists are advised to keep their
skidding under control, following a
downpour in the winter of 1960.

Sail away ... A couple look out across the water in South Shields, 1968.

RIGHT The 1972 hen-party look. I stumbled across this bride-to-be outside my office in Manchester mid-afternoon one day.

OVERLEAF Fish and chips, Oldham, 1980.

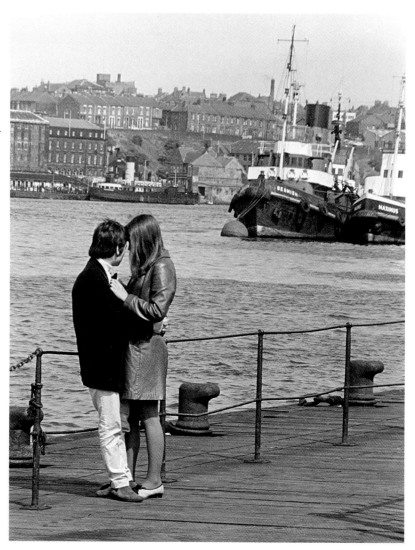

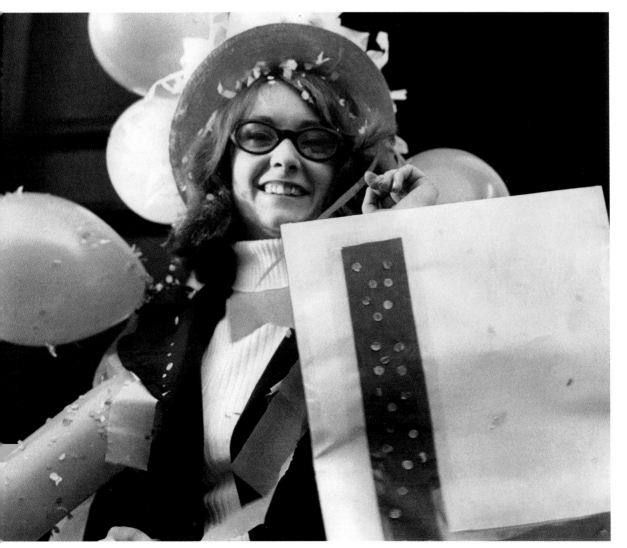

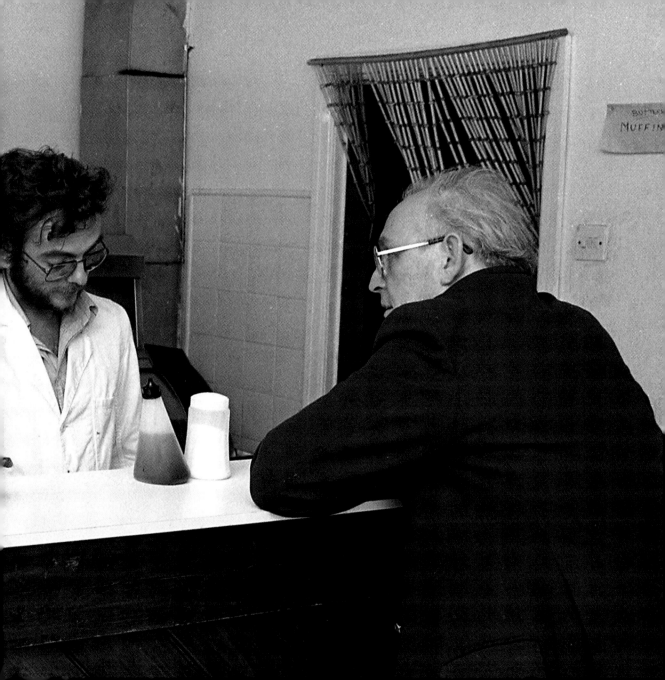

PIG SICK

Notorious high-rise flats in Everton whose level of vandalism led to their being known as 'the Piggeries'. Built in 1965, they were demolished in late 1987 – 12 years after these photos were taken.

LEFT Everton, 1972.

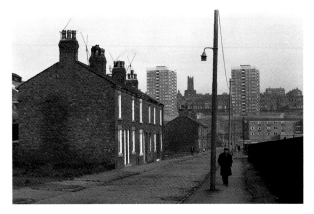

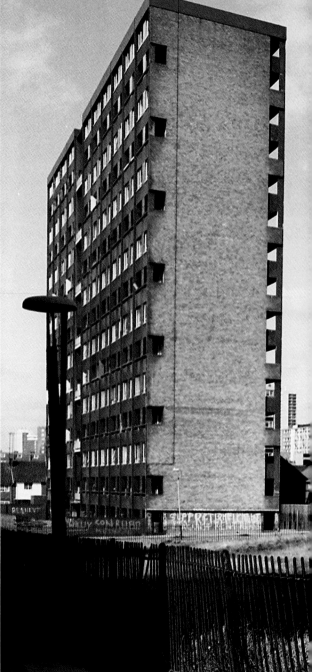

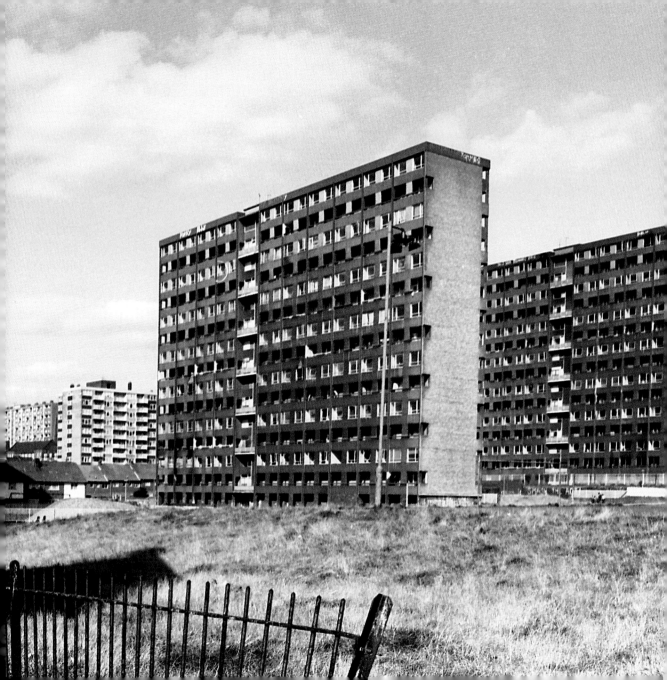

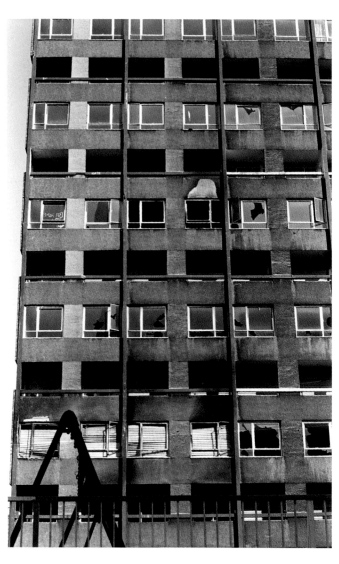
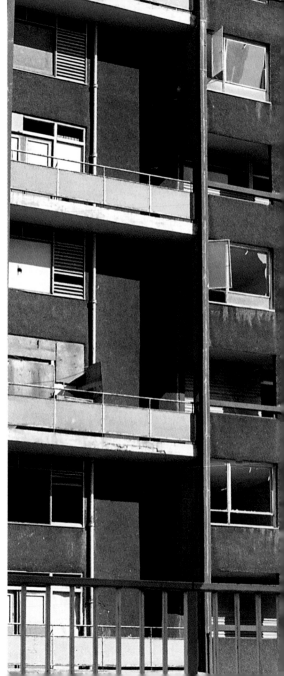

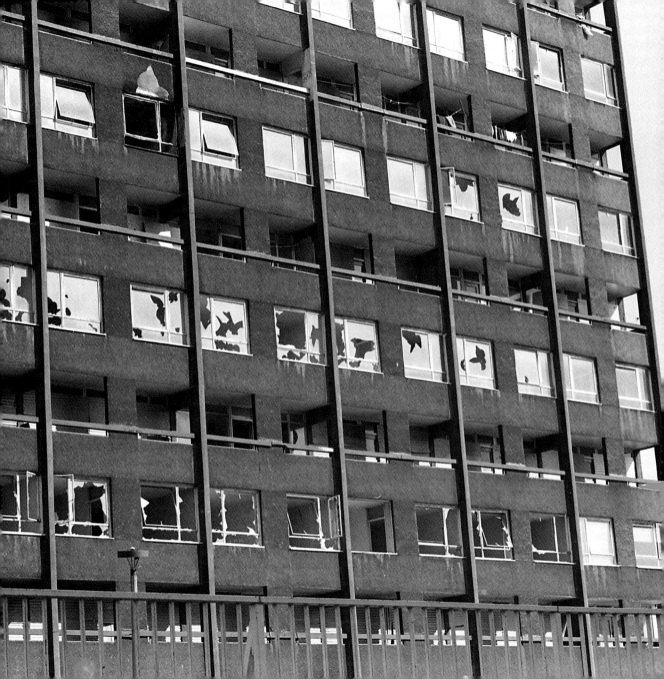

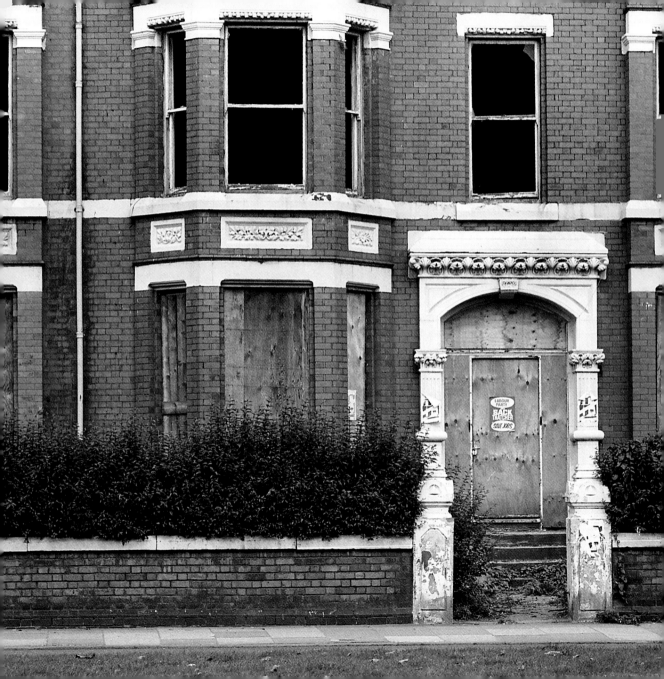

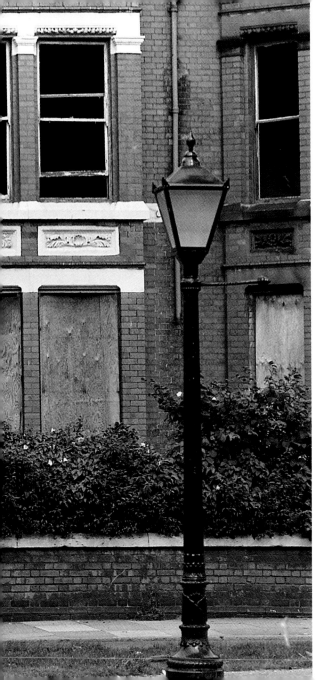

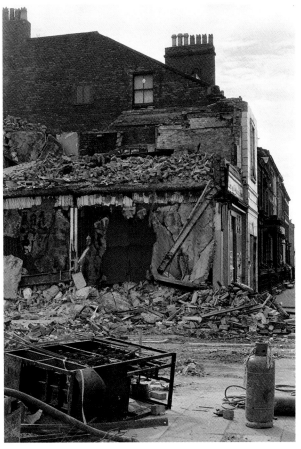

Toxteth has seen better days – the aftermath
of the riots which, like those at Moss Side,
broke out in 1981.

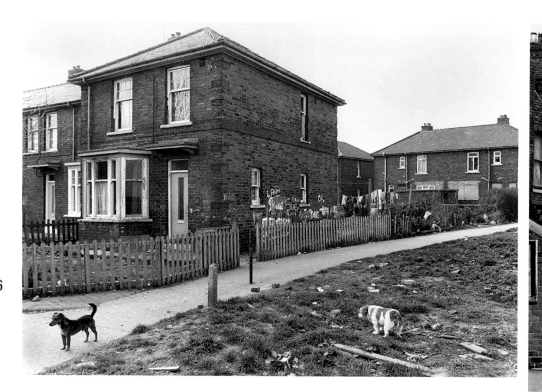

Billingham, in Stockton-on-Tees, 1987. Since the 1920s,
the town has been closely linked to chemical manufacturing.
A visit to a high-tech chemical plant by the author Aldous
Huxley is said to have inspired his work *Brave New World.*

RIGHT A dog keeps watch in Sunderland, 1968.

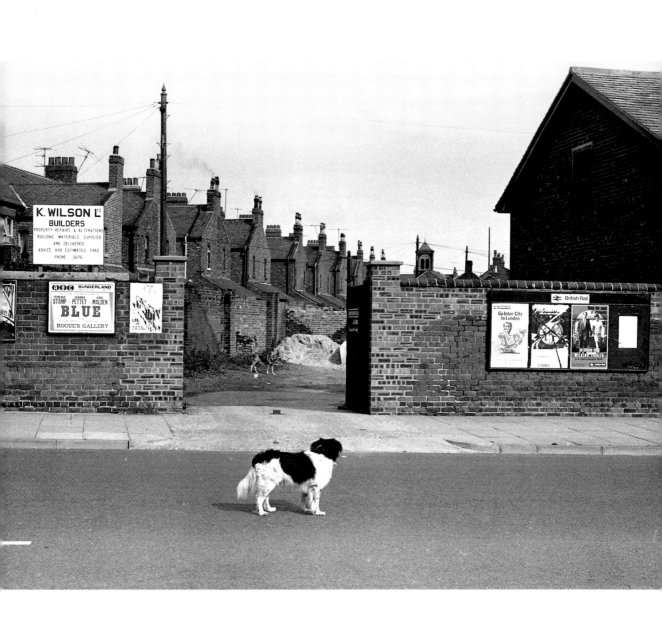

ACKNOWLEDGEMENTS

I would like to thank my son Tim for his passion and persistence in bringing this project to fruition; my long-suffering friends, family and wife Ann for the prolonged periods of life spent hidden away in the darkroom; the fantastic team at Ebury of Jake Lingwood, Hannah Knowles, Imogen Fortes, Toby Clarke, Allan Somerville and Anna Carroll; and the excellent support of John Ryan, Simon Trewin, Alex Proud, Janet Lee, Tom Wilkie and Richard Tucker.

INDEX

NORTHERNERS